Nikon

SB-24

FLASH SYSTEM

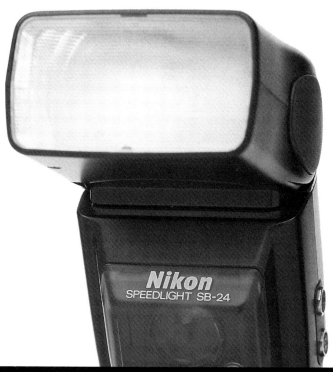

HOVE FOTO BOOKS　　John Clements

Nikon SB-24 Flash System

First English Edition September 1991
New Second Edition March 1992
Published by Hove Foto Books
34 Church Road, Hove, Sussex BN3 2GJ

Production Editor: Georgina Fuller
Design & typesetting: *Facing Pages*, (0273) 593508 England
Printed by The Bath Press, England, BA2 3BL

British Library Cataloguing-in-Publication Data.
A catalogue record for this book is available from the
British Library

ISBN 1-874031-00-2

UK Distribution: USA Distribution

Newpro (UK) Ltd. The Saunders Group
Old Sawmills Road 21 Jet View Drive
Faringdon, Oxon Rochester, NY 14624-4996
SN7 7DS Fax: 716-328-5078

Contents

Introduction – The System Speedlight

The SB24 Speedlight has built up an incredible following amongst photographers since it was launched in 1988. This success can be attributed to its many features, such as the numerous TTL flash exposure options, rear curtain synchronisation, stroboscopic flash, real-time angle-coverage adjustment, as well as an outstanding guide number of 42m (138ft) with a 50mm,f/1.4 lens/100 ISO, to name but a few. No other flashgun has been so eagerly accepted by professional and advanced amateur users.

The SB24 uses the latest microprocessing technology to communicate with the camera body and the lens CPU in the professionally-orientated *F4 and N8008/F801 series* cameras. These cameras are fully compatible with all of the flashgun's specifications.

The same form of communication is used in the *N6006/F601 and N4004/F401 series*, along with the *N2020/F501* camera, for the most frequently used functions. However, any Nikon SLR camera, going back to the original *Nikon F* of 1959, can take advantage of many of the SB23 features. This book gives guidance on the compatibility of the SB24 with each and every Nikon SLR to date – around 50 in all – along with the *Nikonos V* camera, which can also use its TTL flash control.

Nikon call all their flashguns Speedlights, and no analysis of the Nikon Speedlight system would be complete without considering the other Speedlight models and accessories which can be interlinked for multiple flash photography.

There is really no substitute for practical experience, but I have sought, through this book, to stimulate those photographers who require both technical

accuracy and artistic control. It is based on my own first-hand experience with the SB24.

The first edition sold out within a few months. I have received many helpful comments and suggestions from readers and I have taken this opportunity to revise and expand the text. I hope I will have helped owners of the SB24 to understand and enjoy this most versatile of flash units.

The book was written for the advanced photographer, but there is a glossary at the back for all terms that are not self-explanatory.

New pictures have been incorporated in this edition which demonstrate further the versatility and universal application of the SB24. Most present-day flash systems, coupled with modern SLR cameras, can be used creatively beyond the stage of simply making ill-lit scenes into well-exposed photographs. The SB24 goes much further. With its wide range of metering options and other unique features it can be made to enhance pictures in very subtle ways so that it becomes a partner in creative photography in situations where flash would never normally by considered.Good reading.

John Clements

Nikon Camera Models

Throughout this book many individual models of Nikon cameras are mentioned, but most Nikon models have been produced in more than one variant. For simplicity, where the variants have common features as far as their interaction with Speedlights in concerned, I have called them a series. However, when a particular camera model has a unique feature in relation to the Nikon Speedlight system, this has been pointed out. These series of cameras are:

Nikon F4 series:	F4, F4S and F4E.
Nikon N8008/F801 series:	N8008/F801 and N8008S/F801S.
Nikon N6006/F601 series:	N6006/F601 and N6006M/F601M.
Nikon N4004/F401 series:	N4004/F401, N4004s/F401s and N5005/F401x.
Nikon F3 series:	F3, F3HP, F3AF, F3T and F3P.
Nikon FM2 series:	FM2 and FM2N.
F2 series:	F2, F2SB, F2A, F2AS and F2H.
Nikon F series:	F, F photomic, F photomic T, F photomic Tn and F photomic FTn.
Nikkormat series:	FS, FT, FTn, FT2 and FT3.
Nikkormat EL series:	EL, EL2 and ELW.

All other Nikon cameras are mentioned individually, except those which differ only in having a databack fitted, e.g. *N4004s QD / F401s QD*.

Profiles of all Nikon SLR cameras, as far as their interaction with Speedlights is concerned, are in Chapter 10.

1. You Have to Start Somewhere

The letter "F" will always pulsate on the SB24 when a non C.P.U. lens is used

Take up the **SB24** and, with the LCD facing you, a compartment will be found down the right hand side. Gently push in the direction of the arrow and lift to allow access. The cover is not removable. In the chamber between the upper battery positions is a white switch. This is set to one of two positions. The top setting will provide a distance readout in metres on the LCD, while the bottom one will provide one in feet when the **SB24** is switched to the **ON** or **STBY** (standby) positions.

The **SB24** is powered by four AA size batteries. They can be backed up by extra cells inside the external battery packs SD7 or SD8, which will significantly improve the performance with a faster recycling time and a greater number of flashes between battery changes.

Alkaline-Manganese

The high number of flashes provided per set of cells, and their universal availability make alkaline-manganese the most obvious choice for irregular use. For constant use of the **SB24** you will benefit from Nickel-cadmium types (below), with regard to recycling times and less demand on the pocket! The output from alkaline-manganese batteries is usually 1.5 volts, but temperatures close to and below 0°C greatly reduce their performance to impractical levels. For those concerned, the energy required to manufacture an AA size alkaline battery is approximately 50-times the energy available from the battery itself.

Nickel-cadmium (NdCD or Nicads)

Nicads have an output of approximately 1.2 volts per cell, which reduces the number of flashes obtained

per set compared to alkaline types. There the disadvantages end, as nicads can be recharged many times and maintain their output in sub-zero temperatures. Regular users will find them much more economical.

Lithium

At the time of writing, this type of cell is becoming available in AA size, 1.5 volts per battery. The manufacturers are making some impressive claims about their performance. ("Don't they always," I hear you say.) Time will tell.

The major benefits would be a more stable output in both low and high temperatures compared to alkaline types. One specificationI have seen quotes 97% output at -10°C, and 60% at -40°C. There is in addition a claim of a ten-year shelf life. There may also be a reduction in heavy metal content such as mercury and cadmium. Nikon service centres or the manufacturers should be able to comment further.

SD8 External Battery Pack

SB24, SB22, SB20 and SB11

A size of 69mm (w), 158mm (h), 25mm (d) and a weight of only 140 grams (excluding batteries) make this the smallest and lightest power pack for the above units.

Attachment is via the external power terminal (remove the Nikon logo below the red panel **SB24, SB22**), and the PC socket. The ready-light on the SD8 illuminates while recharging takes place, and goes out on completion.

Number of flashes and recycling time at manual full light output:

Battery type	Number of flashes (approx.)*	Recycling time (approx.)
AA-type alkaline-manganese	100 times	7 sec.
AA-type NiCd	40 times	5 sec.
C-type alkaline-manganese inside the optional SD-7**	Up to 200 times Up to 300 times Up to 400 times	6 sec. 10 sec. 30 sec.

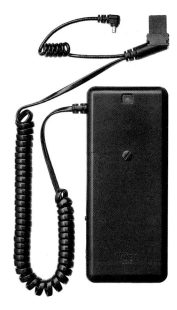

An optional screw and attachment mat allows the SD8 to be attached to the camera's tripod bush. It should also be noted that the SD8 is small enough to fit into most shirt pockets. Six AA size batteries are required, they must be the same type as those in the Speedlight.

Tip: In my experience, large lead-acid or nicad battery packs may shorten the life expectancy of the SB24, Nikon service centres can offer further advice.

■ Specifications

Batteries: Six AA-type alkaline-maganese, NiCd (rechargeable) batteries. (Do not install NiCd batteries in the SD-8 and SB-11 when the SB-11 is used.)

Battery type	AA-type alkaline-manganese battery (Installed in Speedlight)		AA-type NiCd battery (Installed in Speedlight)	
Speedlight**	Min. recycling time* (approx.)	Number of flashes* (approx.) and recycling time.	Min. recycling time* (approx.)	Number of flashes* (approx.) and recycling time.
SB-24	3 sec. (fresh battery)	100 times (3 to 5 sec.) 200 times (3 to 9 sec.) 250 times (3 to 30 sec.)	2 sec. (fresh battery)	100 times (2 to 30 sec.)
SB-22	1.5 sec. (fresh battery)	200 times (1.5 to 2 sec.) 400 times (1.5 to 3 sec.) 550 times (1.5 to 30 sec.)	1 sec. (fresh battery)	220 times (1 to 30 sec.)
SB-20	2 sec. (fresh battery)	100 times (2 to 4 sec.) 200 times (2 to 5 sec.) 350 times (2 to 30 sec.)	1.5 sec. (fresh battery)	130 times (1.5 to 30 sec.)
SB-11***	2.5 sec. (fresh battery)	100 times (2.5 to 5 sec.) 200 times (2.5 to 6 sec.) 350 times (2.5 to 30 sec.)	Not available	

(Batteries are the same in both Speedlight and SD-8)

* At manual full output
** Without using the autofocus assist illuminator LED.
*** Load AA-type alkaline-manganese batteries in both SD-8 and SB-11 when the SB-11 is used. Do not install NiCd batteries.

A Trip Round the SB24

The **SB24** has a tough polycarbonate body. Below the head, at the front, is a large red panel from which an infrared beam is projected in certain lowlight shooting situations. This is to assist the autofocus system on the *F4, N8008/F801, N6006/F601, N4004/F401 series and the N2020/F501 camera*. The effective range of the beam is from 1 to 8 metres, with a 100 ISO film and a 50mm,f/1.8 lens. Bottom right of the panel is the measurement sensor for AUTOFLASH control.

Underneath the panel is a removable NIKON logo, hiding the external power socket for the SD7 and SD8 battery packs.

Turning the **SB24** to the left, we find at the top a rubber pad for a better grip for the fingers. This is used to adjust the position of the head. There are also two connection terminals on this side of the **SB24**. The top one is a three-pin socket for the **TTL**-dedicated leads, SC18 and SC19. The second is the traditional coaxial PC socket.

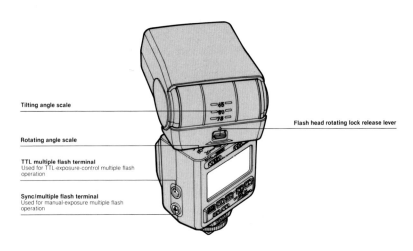

Tilting angle scale

Flash head rotating lock release lever

Rotating angle scale

TTL multiple flash terminal
Used for TTL-exposure-control multiple flash operation

Sync/multiple flash terminal
Used for manual-exposure multiple flash operation

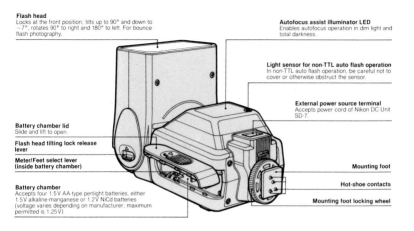

Flash head
Locks at the front position; tilts up to 90° and down to −7°; rotates 90° to right and 180° to left. For bounce flash photography.

Autofocus assist illuminator LED
Enables autofocus operation in dim light and total darkness.

Light sensor for non-TTL auto flash operation
In non-TTL auto flash operation, be careful not to cover or otherwise obstruct the sensor.

External power source terminal
Accepts power cord of Nikon DC Unit SD-7.

Battery chamber lid
Slide and lift to open.

Flash head tilting lock release lever

Meter/Feet select lever (inside battery chamber)

Mounting foot

Hot-shoe contacts

Battery chamber
Accepts four 1.5 V AA-type penlight batteries, either 1.5 V alkaline-manganese or 1.2 V NiCd batteries (voltage varies depending on manufacturer; maximum permitted is 1.25 V).

Mounting foot locking wheel

On the opposite side of the **SB24** is a spring-loaded lock. When this is pushed and held forward, the head can be raised up to 90°: the 45°, 60° and 75° intermediate positions are marked at the back between the head and main body above the LCD panel.

The back of the **SB24** shows a large LCD screen. Above it are six control positions marked **REAR, NORMAL, A, M, STROBE** and **TTL**. Two switches

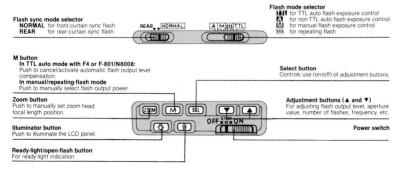

Flash sync mode selector
NORMAL for front-curtain sync flash
REAR for rear-curtain sync flash

Flash mode selector
TTL for TTL auto flash exposure control
A for non-TTL auto flash exposure control
M for manual flash exposure control
for repeating flash

M button
In TTL auto mode with F4 or F-801/N8008:
Push to cancel/activate automatic flash output level compensation.
In manual/repeating-flash mode
Push to manually select flash output power.

Select button
Controls use (on/off) of adjustment buttons.

Zoom button
Push to manually set zoom head focal length position.

Adjustment buttons (▲ and ▼)
For adjusting flash output level, aperture value, number of flashes, frequency, etc.

Illuminator button
Push to illuminate the LCD panel.

Power switch

Ready-light/open-flash button
For ready-light indication

15

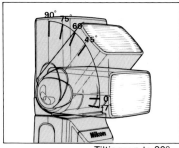

Tilting: up to 90° —front—down to −7°

Rotation: to right 90° —front—to left 180°

Hotshoes of the latest Nikon cameras contain four contact points. The centre one is the X contact. Bottom left is the readlight contact. The other two are TTL contacts. Top right is known as the TTL monitor. It allows confirmation that the SPEEDLIGHT attached is TTL dedicated. Bottom right is the contact from which the stop signal is transferred to the SPEEDLIGHT, when the correct exposure has been reached at the film plane

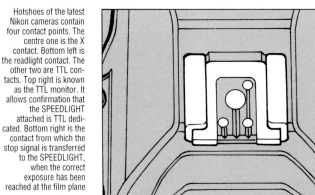

Off-camera flash was used for this photograph. Full dedication between the SB24 and Nikon F4s was maintained by a SC17 lead. Matrix TTL flash was used.
(Photo: David Higgs)

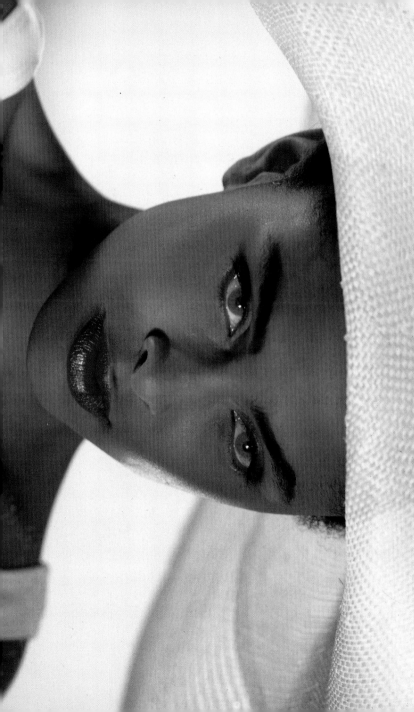

with white markers allow the setting of these controls. Above is a second spring-loaded button for rotating the head up to 180° anticlockwise, or 270° clockwise.

Underneath the LCD panel are six rubber buttons marked **ZOOM, M, SEL**, two **Adjust** buttons and the last one with a sun symbol. In additions are the ready-light, power **OFF, STBY** (stand-by) and power **ON** positions. They are controlled by a sliding switch, with a white index mark.

Finally near the base, a knurled ring rotates to clamp the **SB24** onto an ISO hotshoe. On the under-side are the contact points for communicating with the camera.

Some photographers dislike the slight play between the Speedlight and the camera. This is perfectly normal, but Nikon service centres can provide an addi-tional component to interface between the two for a tighter fit.

Control Buttons and Settings

ZOOM Button

All cameras

This button controls the angle of coverage for flash illumination. Inside the flash head, the flash tube has its position adjusted by a rack-and-pinion system, while the internal diffusing system is adjusted in unison. The coverage can be set for 24mm, 28mm, 35mm, 50mm, 70mm and 85mm focal lengths. Each press of the **ZOOM** button changes the focal length indication (bottom left of LCD panel) next to the word "ZOOM" to indicate that manual control is in use.

When *F4 and N8008/F801 series* cameras are used with CPU lenses, an optional automatic adjustment is available. To use this feature press the **ZOOM** button repeatedly until "85mm" shows on the LCD. One more

Centre-weighted TTL flash in close-up photography.
(Photo: B. Margollis)

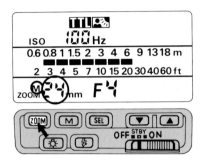

press takes the system into its automatic adjustment setting at which stage the "M" will disappear. Ideal with zoom lenses, the auto adjust can be cancelled with one press of the **ZOOM** button.

N.B. The camera must be switched on to allow CPU communication.

Tip: For a creative vignette set the focal length on the **SB24** *to longer than the lens in use.*

When a change is made to the **ZOOM** setting, the distance indication on the LCD will automatically adjust to indicate the new working distance.

Illumination Button

All cameras

Situated bottom left of the **SB24**, it is marked with a sun symbol. One press provides an agreeable green illumination in low light levels which lasts approximately 8 seconds.

Illuminator button
Push to illuminate the LCD panel.

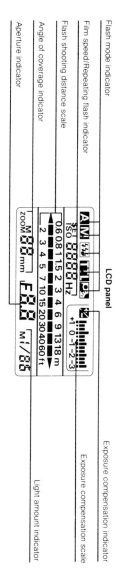

Flash mode indicator

Film speed/Repeating flash indicator

Flash shooting distance scale

Angle of coverage indicator

Aperture indicator

LCD panel

Exposure compensation indicator

Exposure compensation scale

Light amount indicator

Interval timer

*F4, N8008/F801, N6006/F601,
N4004/F401 series and N2020/F501
camera*

Set the **SB24** to the **OFF** position. Press the
illumination button and switch to the **STBY**
position simultaneously. All LCD characters
pulsate and the illumination comes on. After
approximately 8 seconds they cease flashing. A
normal readout is then displayed. Every hour
the **SB24** will now automatically charge ready
for use. Nikon estimate up to 20 days use can be
obtained with fresh alkaline batteries at 20°C.

M Button

All cameras

M button
In TTL auto mode with F4 or F-801/N8008:
Push to cancel/activate automatic flash output level
compensation.
In manual/repeating-flash mode
Push to manually select flash output power.

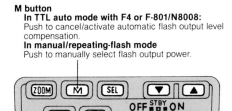

The **M** button has more than one function. One
press is sufficient to change a control.

In **MANUAL** output the **M** button
adjusts the power level. With **TTL** FLASH, a
press changes MATRIX **TTL** FLASH to
MATRIX **TTL** BALANCED FILL-FLASH,
CENTRE-WEIGHTED **TTL** FLASH to
CENTRE-WEIGHTED **TTL** FILL-FLASH, *(F4
and N8008/F801 series only)* and SPOT **TTL**
FLASH to SPOT **TTL** FILL-FLASH *(N8008s/
F801s and N6006/F601 cameras)*.

SEL Button

All cameras

For AUTOFLASH, MANUAL FLASH and STROBE FLASH operation cameras other than *F4 and N8008/F801* require the ISO and f/stop information keyed into the **SB24**.

One press of the **SEL** button starts the letters "ISO" flickering, it will last for 9 seconds, during which the triangular-shaped buttons are used to change the ISO readout. If no change is made, or 9 seconds after it is made, the letter "F" will pulsate, allowing the change to be made to the f/stop, with the **Adjust** buttons.

When in **TTL** flash control *(F4 and N8008/F801 series)*, the **SEL** button, when pressed, allows **TTL** flash level compensation to be activated.

During STROBE FLASH operation the **M** button changes the output level from 1/8th power to 1/16th power if required by the photographer.

Select button
Controls use (on/off) of adjustment buttons.

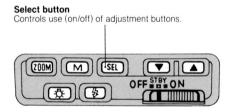

The REAR Position

For using **REAR CURTAIN TTL** (second curtain synchronisation) flash with the *F4 and N8008/F801 series*. The **SB24** should be set to **TTL**.

The NORMAL Position

Apart from **REAR CURTAIN TTL** flash with *F4 and N8008/F801 series*, all other types of flash control and all other cameras are used with the selector switch at the NORMAL position (front curtain synchronisation).

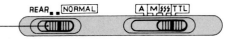

Flash sync mode selector
NORMAL for front-curtain sync flash
REAR for rear-curtain sync flash

The A Position

Sets the **SB24** to AUTOFLASH control with all cameras.

The M Position

Allows MANUAL FLASH output control, *with all cameras*. Both **NORMAL** and **REAR** curtain synchronisation is possible. The latter requires careful consideration to obtain correct exposure.

The STROBE Position

Most Nikon cameras can use the STROBE FLASH feature when this position is selected. The **NORMAL** position is also used.

The TTL Position

Is set for *ALL* **TTL** flash operations on *F4, N8008/F801, N6006/F601, N4004/F401 series, FA, FE2, N2020/F501, N2000/F301 and FG cameras.*

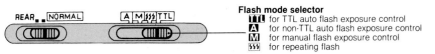

Flash mode selector
TTL for TTL auto flash exposure control
A for non-TTL auto flash exposure control
M for manual flash exposure control
↯↯↯ for repeating flash

AF Assist Panel

This red panel has an LED beam projected through it to assist with autofocus operation in lowlight levels. The **SB24** has an effective range of approximately 1 to 8m (100 ISO, 50mm,f/8 lens).

Lowlight Assistance

F4, N8008/F801, N4004/N401 series,
N6006/F601 and N2020/F501 cameras

With the Speedlights **SB24, 23, 22** and **20** an LED beam is projected from the red panel at the front of the Speedlight, in situations where the AF detection system cannot cope, possibly due to low contrast, prominent of course in low light.

It will only work with Autofocus cameras in a Single Servo AF, where the subject is presumed to be relatively stationary. In continuous servo the subject is presumed to be moving. See the Speedlight description for effective ranges.

F and the LCD

All cameras

The letter "F" will always pulsate on the **SB24** when a non-CPU lens is used. Cameras other than the *F4 and N8008/F801 series*, even with CPU lenses, will not provide a steady "F" on the **SB24** LCD.

The distance display on the LCD is steady if the head is in the normal position. Should you be working with the **SB24** closer to the subject than 1.5m, the head should be adjusted downwards by 7°, the distance scale will flicker on and off as a warning that the head is not at its normal setting.

For **TTL** and **AUTOFLASH**, a recommended shooting range will be displayed. In **MANUAL** and **STROBE** flash control, an LCD block appears, at a specific distance to obtain correct exposure. When the head is set for bounce flash or swivelled, no distance

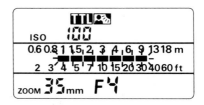

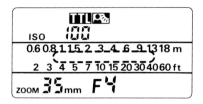

scale appears, as the **SB24** does not know how far the flash now has to travel.

Adjust Buttons

All cameras

As discussed, these buttons are used to make changes on the **SB24** for film speed and f/-stop indications on the LCD panel *(not F4, N8008/F801 series)*, **TTL** flash level compensation *(F4 and N8008/F801 series)* and during STROBE FLASH operation *(all cameras)*. One press for each adjustment step is needed.

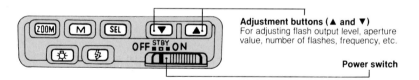

Adjustment buttons (▲ and ▼)
For adjusting flash output level, aperture value, number of flashes, frequency, etc.

Power switch

Ready-Light

Move the power switch to **ON** *(all cameras)* or **STBY** *(F4, N8008/F801, N6006/F601, N4004/F401 series, N2020/F501, N2000/F301, FA, FE2 and FG cameras)*. An electrical current is drawn from the batteries and stored in the capacitor.

When the capacitor is approximately 80 per cent full, two ready-lights, one on the Speedlight and the

other in the viewfinder of a dedicated camera illuminate. (But not with a PC connection.)

The Speedlight can now be triggered, knowing that the output on **TTL** *(F4, N8008/F801, N6006/F601, N4004/F401 series, N2020/F501, N2000/F301, FA, FE2 and FG cameras)* or **AUTOFLASH** *(all cameras)* can, if required, be near full power. On manual output control the output level will be as set.

Other Functions

With **TTL** flash control cameras – *F4, N8008/F801, N6006/F601, N4004/F401 series F3, F3HP, F3T, N2020/F501, N2000/F301, FA, FE2 and FG* – an underexposure warning is provided by the ready-light.

This happens after exposure, when the ready-light will flicker rapidly if underexposure may have occurred. **N.B.** If you are experimenting with no film in the camera, then, as the **TTL** sensor reads the flash illumination reflected from the film plane, it will be the black (low reflectance) backplate which may lead to underexposure warnings.

With *FA, FE2 and FG cameras*, the ready-light flickers before exposure if non-electronic shutter speeds are set, i.e.: *FA/FE2-M* 1/125th of a second, *FG-M* 1/90th of a second.

When set to **TTL** flash control, the **SB24** and camera ready-lights flicker when an *F3, F3HP, F3T or F3AF camera* are connected. (**TTL** flash for the F3 series is only possible with **SB17, SB16A, SB140, SB14, SB11, SB12** (discontinued) or **SB21A** Speedlights).

The ready-light will also flicker when any other non-**TTL** compatible camera is attached to the **SB24** if it is set to the **TTL** position.

The recommended ISO range should not be exceeded for the camera in use. The ready lights will flicker if this happens.

25/1000 ISO	*F4 series/F801 series/F601 series/ N2020/F501, N2000/F301*
25/800 ISO	*N5005/F401x*
25/400 ISO	*N4004S/F401S, FA, FE2 and FA*

The ready-light also pulsates if *FM2 or FE cameras* are set to shutter speeds faster than is possible for synchronisation. During recharge in all modes of use, the ready-lights are not illuminated.

It is possible to reduce the sensitivity of the **TTL** flash metering cell further by placing a fogged and processed piece of film over it. This is useful when working with slow ISO speeds, for example 6 ISO slide duplicating film. But do not forget that any damage you cause by interfering with the unit in this way will invalidate any Nikon warranty. Test exposures should also be made to determine the accuracy of the sensor.

AUTOFLASH can also give underexposure warnings with rapidly pulsating ready-lights, after a **TEST** button is pressed or the shutter released. The ready-light on the Speedlight doubles as a **TEST** button, for a pre-shutter release exposure check. One press of the button triggers the flash. Should both ready-lights then flicker, underexposure will result unless one or more of the following changes are made:

– Flash-to-subject distance shortened.

– The aperture widened.

– The **ZOOM** head positioning set at a longer focal length, but make sure sufficient coverage is maintained for the lens in use.

As the sensor for AUTOFLASH is located on the Speedlight, a film or grey card does not need to be in the camera.

Finally, one observation of my own. The Nikon Speedlight system pulsates the ready-lights ONLY if the shot has been/will be underexposed. I prefer this to other flash systems which pulsate the ready-lights after exposure if it has been correct. I only want to see the flashing lights, taking my eye away from the subject in the viewfinder, in an emergency!

2. Now You See It, Now You Don't

Interior Flash Control

There are three ways to control the amount of flash illumination that reaches the emulsion for interior flash photography with the **SB24**:

TTL Flash

F4, N8008/F801, N6006/F601, N4004/F401 series, N2020/F501, N2000/F301, FA, FE2, FG, F3, F3HP and F3T

Autoflash

All cameras

Manual Flash

All cameras

All have their merits, as will be seen. It should be remembered that in their most basic form each allows the flash illumination to become the *dominant* light source, i.e. MATRIX TTL, CENTRE-WEIGHTED TTL and SPOT TTL, but any can be used to allow ambient light to be the major effect during FILL-FLASH and BALANCED FILL-FLASH operation.

This chapter deals with the way the **SB24** can be used to provide the dominant light source when ambient light levels are low:-

Manual flash control, Autoflash control, Matrix **TTL**,Centre-weighted **TTL** and Spot **TTL**

As **TTL** metering is now the most commonly used measurement of light, both for ambient and flash illumination, we shall primarily look at MATRIX, CENTRE-WEIGHTED and SPOT **TTL** flash control.

Standard TTL Flash

F4, N8008/F801, N6006/F601, N4004/F401 series, N2020/F501, N2000/F301, FA, FE2, FG and Nikonos V

The **TTL** flash system can, depending on the camera, be used with Matrix, Centre-weighted and Spot metering.

When it is used as the dominant light source it is called MATRIX **TTL**, CENTRE-WEIGHTED **TTL** or SPOT **TTL** flash, depending on the metering system set on the camera. All are referred to as STANDARD **TTL**, to differentiate them from when the **TTL** control is used as a complementary light source to strong ambient light, such as daylight. In the latter they are referred to as MATRIX-BALANCED FILL Flash, CENTRE-WEIGHTED FILL FLASH and SPOT FILL FLASH depending on the metering system set on the camera. We will take a look at FILL FLASH operation in the next chapter.

If **TTL** flash is acting as a complementary light source, MATRIX-BALANCED FILL-FLASH, CENTRE-WEIGHTED FILL-FLASH and SPOT **TTL** FILL-FLASH are the options, depending on the camera setting.

A common sense, but easily overlooked feature, is the ability of the camera's computer to switch the **TTL** FILL FLASH system automatically to the STANDARD **TTL** types when it feels it is needed.

The Nikon cameras capable of **TTL** flash control use a Silicon Photo Diode, on the floor of the light path, behind the mirror. It faces the film plane and measures the amount of flash illumination reflected from the film.

N.B. If neither an emulsion nor grey card is placed in the film gate, the amount of flash illumination

reflected to the sensor off the black backplate is small. In most instances an underexposure warning from

the ready-lights will be given. At first pressure on theshutter release, an assessment is made of the shutter speed, f/stop and ISO in use. Changes are made by the camera, if needed, to f/stop and/or shutter speed (not if the camera is in manual exposure mode). As all metering systems are based on the theory of 18 per cent reflectance, the camera can now monitor the amount of illumination reaching the SPD and command the Speedlight to quench exposure in real-time, once sufficient exposure has been received, for an 18% reflectance to be reproduced as such. Subjects not of average reflectance will benefit from **TTL** flash compensation *(F4, N8008/F801 series and N6006/F601).*

TTL Flash – Interior Shooting

When ambient light levels are low (or low enough in the photographer's opinion), **TTL** flash control can be used as the primary light source.

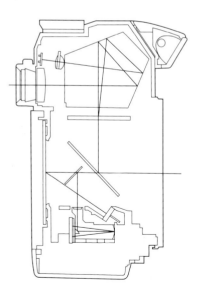

Exposure Control Flow Chart

For TTL flash exposure control all of this happens in realtime

31

MATRIX **TTL**, CENTRE-WEIGHTED **TTL** and SPOT **TTL** are the options available, depending on the camera in use. The differences in the analysis of the scene and the resulting exposure are due to the characteristics of each metering type, as is the case with available-light exposures. These have been dealt with in detail for the Nikon cameras concerned in the relevant Hove books (see back cover), so only a brief resume will be given.

MATRIX TTL

F4, N8008/F801, N6006/F601 series,
N5005/F401x

The SPD cells in the camera's viewfinder measure the amount of ambient light. Different parts of the SPD measure specific areas only of the picture area. This information is fed into the camera's computer. An outline not only of the brightness levels in specific areas, but also the total picture area can then be established. In addition, the contrast (by comparing the brightness in different parts of the scene) can be measured. This happens in realtime.

From this point the camera tries to find a match for the distribution of brightness and contrast in its memory.

The memory data has been stored in the camera's computer, and consists of thousands of professionally taken images, which Nikon's R&D teams have analysed. Their aim has been to work out how professionals view exposure of a given subject, and the decisions that were taken to achieve it. For example, increasing/decreasing exposure for difficult lighting such as backlighting, which would normally lead to underexposure of the main subject.

We do not wish to over-simplify the Matrix metering capabilities. By using a multi-pattern metering system such as Matrix, instantaneous, technically correct exposures can be made without time-consuming calculations.

The Matrix system is generally more accurate than centre-weighted metering, particularly for off-centre, strong side-lighting or backlit subjects, as it needs little or no adjustment for many common situations. Compared to Spot **TTL**, time does not have to be allowed for accurate meter alignment, or the experience to use Spot **TTL** wisely.

MATRIX TTL Flash Applications

There are three main reasons why professional requirements can be met with this form of flash illumination.

Firstly, it gives rapid response in situations that may be changing greatly in terms of subject or background reflectance, for example fashion and press photography.

Second, it can be used when the composition is changing rapidly, possibly with the main subject off-centre, e.g. action photography such as boxing. The background is not important, so there is no need for a FILL-FLASH mode, while a constantly changing subject position makes a constant readjustment of output for an off-centre subject impractical.

Thirdly, MATRIX **TTL** can be generally relied upon to provide a result when the photographer is unsure of the exposure required to provide a technically correct result, or when we may wish to give our attention to other things such as the constant communication and prompting of a model during a shoot.

Using MATRIX TTL Flash with the SB24

F4, N8008/F801 and N6006/F601 series

The camera should be set for Matrix metering. Cameras, other than the *F4 series*, must have a CPU lens attached (AF or AIP Nikkor lenses). The F4 series provides Matrix metering with manual focus AI or AIS type lenses (AI modified lenses do NOT provide Matrix metering). The **SB24** should be set at the NORMAL and **TTL** positions.

With the *F4 and N8008/F801* series, a symbol showing a head and shoulders, and a sun symbol appear next to the letters "TTL" on the **SB24** LCD.

FIG21

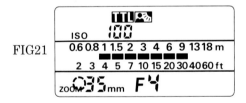

If this symbol is steady, MATRIX-BALANCED FILL-FLASH is in use. To change to MATRIX **TTL** flash, press the **M** button once, the symbol pulsates, MATRIX **TTL** flash is in operation.

On the *F4 and N8008/F801 series*, the f/stop and ISO information is transferred automatically between Speedlight and body, via a CPU in each, once they are

A single on-camera flash with Nikon F4s and SB24 Speedlight providing Matrix TTL was also used here.
(photo: Patrick Lauson – Sportsgraphic)

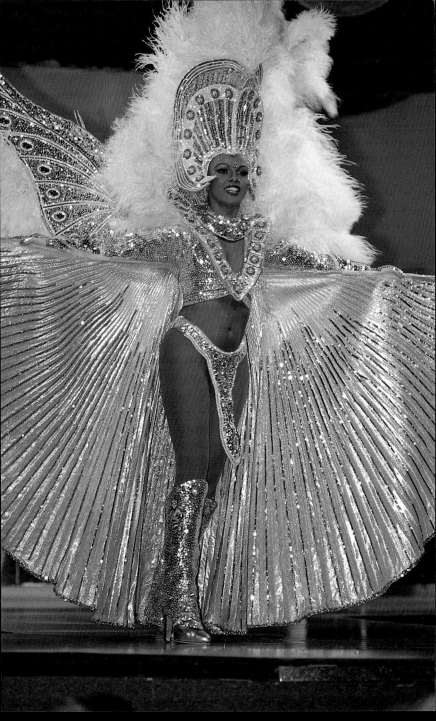

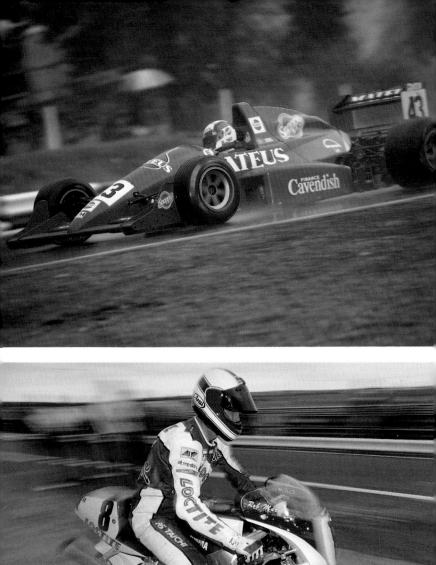
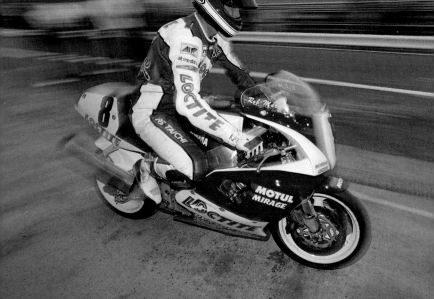

Flash output level (In Matrix Metering, with lens f/5.6 or faster)

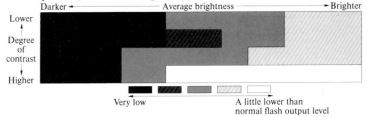

Darker ◄──────────── Average brightness ────────────► Brighter

Lower ▲
Degree
of
contrast
▼
Higher

Very low A little lower than
normal flash output level

Shutter Speed/Aperture and Flash Mode Combinations for Each Exposure Mode In Matrix Metering (with 50mm f/1.4 lens at ISO 100)

Ex-posure mode	Speed-light SB-24						SB-23/22/20/18/16B/15	
	Front-curtain sync			Rear-curtain sync			TTL	Non-TTL auto Manual
	TTL 📷	TTL 📷	Non-TTL auto Manual	TTL 📷	TTL 📷	TTL		
PD P PH	1/60–1/250 f/4–f/16 (1)	1/60–1/250 f/4–f/16 (1)	P, FEE blink Shutter locks Select A or M	30"–1/250 f/4–f/16 (1)	30"–1/250 f/4–f/16 (1)	1/60–1/250 f/4–f/16 (1)	P, FEE blink Shutter locks Select A or M	
S	As set (3) f/2.8–f/16 (2)	As set (3) f/2.8–f/16 (2)	S, FEE blink Shutter locks Select A or M	As set (3) f/2.8–f/16 (2)	As set (3) f/2.8–f/16 (2)	As set (3) f/2.8–f/16 (2)	S, FEE blink Shutter locks Select A or M	
A	1/60–1/250 As set	1/60–1/250 As set	1/60–1/250 As set (4)	30"–1/250 As set	30"–1/250 As set	1/60–1/250 As set	1/60–1/250 As set (5)	
M	As set (3) As set	As set (3) As set	As set (3) As set (4)	As set As set	(3) As set (3) As set	As set (3) As set	As set (3) As set (5)	

▱ : Matrix Balanced Fill-Flash (background correctly exposed; TTL flash level automatically compensated)

▱ : Matrix TTL Flash (background correctly exposed; standard TTL flash)

(1) Maximum usable aperture varies according to film speed in use; minimum aperture is the smallest aperture of the lens in use.

(2) Maximum usable aperture is f/2.8; minimum aperture is the smallest aperture of the lens in use.

(3) When set from 1/250 to 1/8000 sec., the shutter is automatically set to 1/250 sec.

(4) Recommended background exposure is displayed. Extra flash level compensation not possible.

(5) Recommended background exposure is displayed. Normal flash control.

Output of matrix TTL flash is based on the brightness and contrast of the scene switched on. The "F" will not flicker. In addition the **ZOOM** head will change its position if required, should it be at the auto setting. The LCD will show the recommended shooting range, with the head in the normal of 7° downward position.

If the same LCD information is wanted with the *N6006/F601 series and N5005/F401x cameras*, the ISO, f/stop and ZOOM settings are manually set.

Top: When the lighting is subdued and flat, fill flash will provide that little sparkle which can make a picture. This was a Matrix Balanced Fill Flash shot, taken with a Nikon F4s and SB24.

Bottom: Rear curtain flash in daylight was used for this image. See Glossary for further details. (photos: Mike Rushton – Prosport)

Use the **SEL, Adjust** and **ZOOM** buttons as previously described. Only the letters **TTL** appear on the **SB24** LCD with the *N6006/F601 series and N5005/F401x cameras*. The change to or from MATRIX **TTL** flash to MATRIX **TTL** BALANCED FILL-FLASH is made by a control on the *N6006/F601*, whilst on the *N5005/F401x*, the computer decides.

N.B. The **TTL** exposure is still controlled by the camera, even if the wrong ISO and f/stop are shown on the SB24.

CENTRE-WEIGHTED TTL Flash

F4, N8008/F801, N6006/F601, N4004/F401 series, N2020/F501, N2000/F301, FA, FE2, FG, F3, F3HP, F3T, F3P and Nikonos V land use

This was the first form of **TTL** flash control incorporated in Nikon cameras (F3 1980). Is uses the characteristics of the Centre-weighted metering system. The *F3* cameras mentioned can only obtain **TTL** abilities with the **SB11, SB14/140, SB17, SB16A** and the discontinued **SB12**. The other cameras mentioned use any of the other **TTL** Speedlights. In the case of the *N4004/F401 and N4004s/F401s cameras*, CENTRE-WEIGHTED **TTL** flash is possible only in manual exposure control.

CENTRE-WEIGHTED TTL Flash Applications

The CENTRE-WEIGHTED **TTL** flash system is preferable when using wide-angle lenses, particularly when the angle of flash coverage has been extended with separate diffusers. In such situations the MATRIX **TTL** system may not "pick up" small subjects, e.g. for a portrait of someone positioned in an area of seating by themselves. If a 20mm lens, for example, is used from far enough away, it may not pick up the main subject.

Subjects with high reflectivity may also mislead the Matrix meter, as would filters with large exposure factors, such as the Nikon R60 (red), so again CENTRE-WEIGHTED **TTL** flash is preferable.

Using CENTRE-WEIGHTED TTL Flash with the SB24

The camera should be set to CENTRE-WEIGHTED metering if it is from the *F4, N8008/F801 or N6006/F601 series*, while a camera from the *N4004/F401 series* must be used in manual exposure control, unless the auto exposure lock is used in program, shutter speed or aperture priority mode. Then CENTRE-WEIGHTED metering overrides evaluative metering.

The *N8008/F801 and N6006/F601 series* along with the *N5005/F401x camera* base 75% of the meter reading from within the 12mm circle in the camera's viewfinder. In the *F3 series*, 80% is measured. All other cameras read 60% from the same area.

Tip: If the subject is off-centre, or to be photographed with normal or wide-angle lenses, move close to the subject if possible, point the metering area over the subject, use an exposure lock on the main subject, then recompose and take the shot. The exposure will now be correct.

Schematic diagram of centre-weighted metering

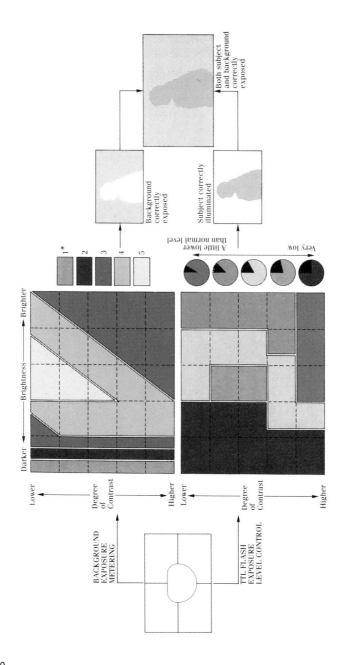

Telephoto or zoom lenses such as the excellent 80-200mm,f/2.8 AF, which fill most of the frame (portraiture, glamour, fashion and photojournalistic types of photography), will not need the use of such a technique. The subject area covered begins to act as a very tight partial reading.

If the head and shoulders symbol next to the letters "TTL" is steady *(F4 and N8008/F801 series)*, press the M button once to set it pulsating. CENTRE-WEIGHTED **TTL** FILL-FLASH is in operation.

On cameras not of the *F4 or N8008/F801 series,* just the letters "TTL" will appear, with no head and shoulders symbol. If accurate guidance appertaining to the working distance is required, the f/stop, ISO and **ZOOM** head controls should be manually set on the **SB24**.

N.B. The **TTL** exposure will be controlled by the camera, without the above controls set.

SPOT TTL Flash

F4 and N8008/F801 series and N6006/F601 cameras

The area covered by the Spot meter varies slightly between the *F4* and the other series of cameras. It measures approximately 5mm in diameter if the viewfinder image in the *F4 series,* and approximately 3.5mm in diameter in the others. For precise area exposures SPOT **TTL** is recommended. This is very useful when the main subject is surrounded by a much higher or lower contrast environment, where the CENTRE-WEIGHTED **TTL** system may lead to incorrect exposures while the MATRIX **TTL** system could be bettered. This would be the case when the subject is very small in relation to the total composition, or is backlighted.

SPOT TTL Flash Applications

SPOT **TTL** flash is the preferred method when:

– The subject is in a high contrast situation, such as backlighting.
– In close-up photography when it allows concentration on the main subject, whereas the other systems might give too much exposure because they include the background in their measurements.

Using SPOT TTL Flash with the SB24

Set the camera's meter to SPOT metering. If using an *N8008/F801 series* camera, check that the head and shoulders symbol is pulsating. If it is not, press the **M** button to start it pulsating. A steady symbol would mean that SPOT FILL-FLASH was in operation.

The *N6006/F601* has its own control button to change from SPOT **TTL** FLASH to SPOT FILL-FLASH. Only the letters **TTL** will appear on the **SB24** LCD.

The *F4 series* can only obtain SPOT **TTL** FILL-FLASH.

Exposure Mode Operation for TTL Flash

F4, N8008/F801 and N6006/F601 series

In Programmed and Aperture Priority modes, the synchronisation speed is controlled between 1/60th and 1/250th second. The 1/60th has priority contrary to the Speedlight *(F4 and N8008/F801 series)* instruction booklets.

The *N6006/F601 series* works on the reciprocal of focal length rule to enable synchronisation between 1/15th and 1/125th for normal flash photography. The *N8008/F801 and N6006/F601 series* also allows slower shutter speeds during slow synch photography, down to 30 seconds. In Shutter Priority and Manual exposure modes, the shutter speed used is as set.

N.B. Too fast a shutter speed above possible synchronisation leads to the camera defaulting to the top possible synchronisation speed.

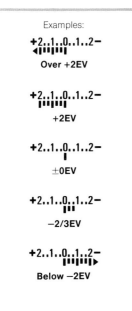

Examples:

+2..1..0..1..2−
Over +2EV

+2..1..0..1..2−
+2EV

+2..1..0..1..2−
±0EV

+2..1..0..1..2−
−2/3EV

+2..1..0..1..2−
Below −2EV

A very clever, but misunderstood feature in the *N8008/F801 and N6006/F601 series* allows a pre-warning of an under/overexposed background.

If a bar graph in Programmed Aperture Priority or Shutter Priority appears on the LCD displays of the camera it refers to the possible background exposure (which flash will not reach).

The flash illumination will correctly expose a foreground subject, but the combined aperture/shutter speed will not be sufficient for a correct (balanced) background exposure with ambient light. Change aperture or shutter speeds until the bar graph centres or disappears for a balanced shot.

N.B. The calculation is based on light meter readings of brightness. Therefore standing a person against

a dark wall may bring up the display, but in reality the flash will cover all the scene.

Speedlight/Camera Combinations for TTL Flash Control

SB24 – *F4, N8008/F801, N6006/F601, N4004/F401 series, N2020/F501, N2000/F301, FA, FE2, FG and Nikonos V* with **TTL** land use lead

SB23 – As above

SB22 – As above

SB20 – As above

SB18 (discontinued) – As above

SB17 – *F3, F3HP, F3AF and F3T*

SB16A – As SB17

SB16B – *F4, N8008/F801, N6006/F601, N4004/F401 series, N2020/F501, N2000/F301, FA, FE2, FG and Nikonos V* with land use **TTL** lead

SB15 (discontinued) – As above

SB14/140 – *F3, F3HP, F3AF and F3T* with SC12 **TTL** lead; *F4, N8008/F801, N6006/F601 series, FA, FE2, FG, N2020/F501, N2000/F301* with SC23 **TTL** lead

SB12 (discontinued) – *F3, F3HP, F3AF and F3T*

SB11 – *F3, F3HP, F3AF, and F3T* with SC12 **TTL** lead; *F4, N8008/F801, N6006/F601 series, FA, FE2, N2020/F501, N2000/F301 and FG cameras* with SC23 **TTL** lead.

An interesting point was made by our friends at Kodak, regarding **TTL** flash metering, to the effect that in a perfect world all of the light that reached the emulsion would be absorbed. This would obviously mean that no light would reflect on to the **TTL** sensor, hence no measurement. Does this means that as emulsion technology progresses the actual reflectance value will reduce?

It should be noted that although different emulsions have slightly different reflectance values, this should not, except in the most precise scientific applications, cause any sleepless nights.

Using the SB24 for AUTOFLASH Control

All cameras

The top controls should be set to the **NORMAL** and **A** positions. Strangely, the *F4 and N8008/F801 series* allow rear curtain flash to be used. But correct exposure?

In all instances the letter "A" is displayed top left on the LCD and the letter "F" pulsates. This acts as a warning to *F4 and N8008/F801 series* users that AUTOFLASH, and not **TTL** flash, has been chosen.

The choice of aperture can be made on depth of field requirements. The **SEL** and **Adjust** buttons are used to key into the **SB24** the desired f/stop and ISO information, if the camera is not from the *F4 or 8008/F801 series.*

Once set, the LCD readout provides guidance on flash-to-subject distances in the normal and 7° head positions. The latter has a pulsating LCD distance scale as a warning.

AUTOFLASH can be used with any ISO setting (6/6400), unlike **TTL** flash, and any camera. Indeed I often use it with my medium-format outfit. Exposure modes that can be used are manual *(all cameras),* or those offering Aperture Priority. Unlike many flashguns, the **SB24** offers 6 f/stop options, from f/2 to f/11 (100 ISO), for greater user freedom.

The drawbacks are few, except when working with accessories requiring an exposure increase, such as bellows or filters, which the sensor on the front of the Speedlight is unaware of. Use one of the **TTL** systems, if possible, in these situations.

The position of the sensor itself can cause problems if it is not parallel with the plane of the main subject. Pay

USABLE APERTURES/SHOOTING DISTANCE RANGE IN TTL AND NON-TTL AUTO FLASH MODES

Unit: meters

| ISO film speed | | | | | | | Shooting distance range | | | | | |
1600**	800*	400	200	100	50	25	Zoom set at 24mm	Zoom set at 28mm	Zoom set at 35mm	Zoom set at 50mm	Zoom set at 70mm	Zoom set at 85mm
2.8	2	1.4					5.2 ~ 20	5.7 ~ 20	6.4 ~ 20	7.5 ~ 20	8.4 ~ 20	8.9 ~ 20
4	2.8	2	1.4				3.7 ~ 20	4.0 ~ 20	4.5 ~ 20	5.2 ~ 20	5.9 ~ 20	6.3 ~ 20
5.6	4	2.8	2	1.4			2.6 ~ 20	2.9 ~ 20	3.2 ~ 20	3.7 ~ 20	4.2 ~ 20	4.4 ~ 20
8	5.6	4	2.8	2	1.4		1.8 ~ 15	2.0 ~ 16	2.3 ~ 18	2.6 ~ 20	3.0 ~ 20	3.2 ~ 20
11	8	5.6	4	2.8	2	1.4	1.3 ~ 10	1.5 ~ 11	1.6 ~ 12	1.8 ~ 14	2.1 ~ 16	2.3 ~ 17
16	11	8	5.6	4	2.8	2	1.0 ~ 7.5	1.0 ~ 8.0	1.2 ~ 9.0	1.3 ~ 10	1.5 ~ 11	1.6 ~ 12
22	16	11	8	5.6	4	2.8	0.7 ~ 5.3	0.7 ~ 5.6	0.8 ~ 6.3	1.0 ~ 7.4	1.1 ~ 8.3	1.1 ~ 8.8
32	22	16	11	8	5.6	4	0.6 ~ 3.7	0.6 ~ 4.0	0.6 ~ 4.5	0.7 ~ 5.2	0.8 ~ 5.8	0.8 ~ 6.2
	32	22	16	11	8	5.6	0.6 ~ 2.6	0.6 ~ 2.8	0.6 ~ 3.1	0.6 ~ 3.7	0.6 ~ 4.1	0.6 ~ 4.4
		32	22	16	11	8	0.6 ~ 1.8	0.6 ~ 2.0	0.6 ~ 2.2	0.6 ~ 2.6	0.6 ~ 2.9	0.6 ~ 3.1
			32	22	16	11	0.6 ~ 1.3	0.6 ~ 1.4	0.6 ~ 1.5	0.6 ~ 1.8	0.6 ~ 2.0	0.6 ~ 2.2
				32	22	16	0.6 ~ 0.9	0.6 ~ 1.0	0.6 ~ 1.1	0.6 ~ 1.3	0.6 ~ 1.4	0.6 ~ 1.5

f/stop

Unit: feet

| ISO film speed | | | | | | | Shooting distance range | | | | | |
1600**	800*	400	200	100	50	25	Zoom set at 24mm	Zoom set at 28mm	Zoom set at 35mm	Zoom set at 50mm	Zoom set at 70mm	Zoom set at 85mm
2.8	2	1.4					17 ~ 66	19 ~ 66	21 ~ 66	25 ~ 66	28 ~ 66	29 ~ 66
4	2.8	2	1.4				12 ~ 66	14 ~ 66	15 ~ 66	17 ~ 66	20 ~ 66	21 ~ 66
5.6	4	2.8	2	1.4			8.6 ~ 66	9.3 ~ 66	11 ~ 66	12 ~ 66	14 ~ 66	15 ~ 66
8	5.6	4	2.8	2	1.4		6.1 ~ 49	6.6 ~ 52	7.4 ~ 59	8.6 ~ 66	9.7 ~ 66	11 ~ 66
11	8	5.6	4	2.8	2	1.4	4.4 ~ 34	4.7 ~ 37	5.3 ~ 41	6.0 ~ 48	6.9 ~ 54	7.3 ~ 58
16	11	8	5.6	4	2.8	2	3.1 ~ 24	3.3 ~ 26	3.7 ~ 29	4.3 ~ 34	4.9 ~ 38	5.2 ~ 41
22	16	11	8	5.6	4	2.8	2.2 ~ 17	2.4 ~ 18	2.7 ~ 20	3.1 ~ 24	3.5 ~ 27	3.7 ~ 29
32	22	16	11	8	5.6	4	2.0 ~ 12	2.0 ~ 13	2.0 ~ 14	2.2 ~ 17	2.5 ~ 19	2.6 ~ 20
	32	22	16	11	8	5.6	2.0 ~ 8.7	2.0 ~ 9.2	2.0 ~ 10	2.0 ~ 12	2.0 ~ 13	2.0 ~ 14
		32	22	16	11	8	2.0 ~ 6.1	2.0 ~ 6.5	2.0 ~ 7.3	2.0 ~ 8.6	2.0 ~ 9.6	2.0 ~ 10
			32	22	16	11	2.0 ~ 4.3	2.0 ~ 4.6	2.0 ~ 5.2	2.0 ~ 6.0	2.0 ~ 6.8	2.0 ~ 7.2
				32	22	16	2.0 ~ 3.0	2.0 ~ 3.3	2.0 ~ 3.6	2.0 ~ 4.3	2.0 ~ 4.8	2.0 ~ 5.1

f/stop

particular attention in this respect with "off the hotshoe" photography.

Manual Flash Control on the SB24

The **SB24** can be connected, depending on the camera in use, by a PC lead, **TTL** dedicated lead SC17, or direct to the ISO hotshoe.

With the *F4 and N8008/F801 series* the Speedlight will fire at the end of the exposure if the top left control is set to **REAR**. In most instances *(and all other cameras)* it will be set to **NORMAL**, so front curtain synchronisation occurs. The right side switch is set at the **M** position.

F4 and N8008/F801 series

The ISO, f/stop and **ZOOM** control information is automatically relayed to the **SB24** when it and the camera are switched on, with AF or AIP lenses. The "F" will not pulsate. With other lens types the letter "F" will always flicker on/off.

When the head is in its normal, or 7° minus, positions, an LCD mark appears to recommend the correct flash-to-subject (not camera-to-subject) distance for correct exposure. Changing f/stop or ISO settings on the camera will induce a change in the recommended working distance on the LCD distance scale.

Such is the flexibility of the **SB24**, the power output on the Speedlight can also be adjusted. This is done by a press on the **M** button. The output indication appears on the bottom right of the LCD panel.

All Other Cameras

Depending on the camera, all three connection types may be possible. The f/stop, ISO and **ZOOM** head have to be set manually on the **SB24**. Use the **SEL** and **Adjus**t buttons as previously mentioned. The letter "F" always pulsates.

The power output is controlled by the **M** button, with the power ratio and flash-to-subject distance shown on the LCD of the **SB24**. When the head is in the normal or downward positions, the output is adjusted in the following sequence: 1/1 (full power), 1/2, 1/4, 1/8 and 1/16 ratios. The effective guide number changes when the power output and or **ZOOM** controls are changed.

Due to the power output of the **SB24** and the availability of many useful diffusing accessories from independent manufacturers, it is possible to achieve studio-type results when working on manual output with more than the one **SB24** linked by leads (cords) or slave cells.

Manual Calculation

It is possible with a known guide number and flash-to-subject distance to calculate the aperture needed for correct exposure.

E.g. Flashgun guide number 55(m), flash-to-subject distance 5m

Divide distance into guide number:
55/5 = 11

Therefore shooting aperture is f/11

Or **SB24** guide number 42(m), flash-to-subject distance 8m

Divide distance into guide number:
42/8 = 5.25

Therefore shooting aperture is f/5.6
(nearest is used)

Painting with Light

The power and size of the **SB24** make it ideally suited for this technique. The subject matter is generally an extremely large internal area, such as a church interior.

It may not be practical to light such an area, which without its own internal light will be extremely dark, with studio flash systems in all circumstances. Not only from the cost point of view but also the lack of access to many non-professionals. What we can do however is to use the following to accomplish a similar result.

Take an exposure with the shutter locked open on the B setting. While the shutter is open the photographer and/or assistants can move around the area to be illuminated, firing the **SB24** into shadow areas. This in its entirety will provide sufficient illumination for such subjects. It is important that the people moving around are dressed in black, so as to reduce the potential of them being recorded on film. The shutter should then be closed.

3. The Art of FILL-FLASH with Nikon

FILL-FLASH and BALANCED FILL-FLASH are often confused. FILL-FLASH decreases the natural shadow areas in the picture, allowing more detail to be recorded. This brings the shadow areas closer to the highlight detail in terms of exposure, thereby reducing the contrast.

This can be achieved by controlling the output of the Speedlight, or the deliberate use of an f/stop smaller than would normally be used for interior (dominant) flash control under similar working criteria - ISO, flash-to-subject distance. Either will allow the ambient light to be stronger for a natural-looking effect. Usually a fast shutter speed, e.g. 1/250th of a second, is chosen.

With FILL-FLASH then, the contrast on the subject is reduced, but the background which flash illumination cannot reach will only be exposed with ambient light at the set aperture and shutter speed. It is unlikely that the exposure of the background (ambient exposure) will be as strong as that of the foreground (ambient and flash combined), due to a faster shutter speed and/or smaller aperture required for the FILL-FLASH control.

BALANCED FILL-FLASH (also called synchro sunlight) will provide the same contrast-reducing effect of the foreground subject, but the use of a sufficient f/stop (wide enough), and/or shutter speed (slow enough), enables the correct, or nearly correct ambient exposure for the background. The flash illumination is then controlled with the set aperture/shutter speed, to avoid overexposure with flash, balancing the two. The flash illumination will not be the dominant light source.

Let us consider the following application of FILL-FLASH and BALANCED FILL-FLASH, for photo-chemical reproduction from our work.

Transparency emulsions are still preferred for many reproduction purposes. The author does however acknowledge that colour negative materials can be considered "good enough" for print in many of today's newspapers. But the quality will not reach that of a positive material for other reproduction purposes.

If we take the Kodachrome and Ektachrome emulsions as a typical example, we will see that they have a recording latitude of around 7 stops from their highlight detail to shadow detail retention, when viewed. (Do not confuse this with exposure latitude.) This range is compressed however when reproduced on paper, to around 3.5 f/stops.

Should it be technically or artistically feasible, FILL-FLASH or BALANCED FILL-FLASH can be used to reduce the contrast on the original image, allowing a reproduction without as many compressed tones. We as photographers will then be happier, as we will see our work reproduced more faithfully to the original tonal range.

MATRIX TTL BALANCED FILL-FLASH

F4, N8008/F801, N6006/F601 series and N5005/F401x camera

MATRIX **TTL** BALANCED FILL-FLASH is today the most advanced automatically controlled system of daylight balanced flash. Using the same calculation method as used for Matrix metering of ambient light, the camera can interpret the overlay of brightness and contrast levels in a scene. It then makes the exposure decision for ambient light, setting the f/stop and shutter speed values (bearing in mind any set parameters in auto modes). This

will enable the ambient light to record sufficient background detail.

At this point the sensor which monitors flash exposure levels is made aware of the required flash illumination for correct exposure and therefore knows at which point to send the stop signal to the Speedlight.

This is generally (but not always) sooner than would be the case with MATRIX **TTL** flash, to illuminate any foreground subject. (The actual amount will depend on the ambient light brightness levels overlay.) It will therefore provide a fill-in effect, but not be the dominant light source. The Speedlight output of illumination during MATRIX **TTL** BALANCED FILL-FLASH is controlled between 0 E.V. (same as MATRIX **TTL**) and -1 E.V. lower than MATRIX **TTL**, under the same shooting situation. The output is chosen from one of five different levels. If the background is particularly bright, then normal (standard) MATRIX **TTL** flash is used to balance background and foreground.

Using MATRIX BALANCED FILL-FLASH with the SB24

Set Matrix metering on the camera. The control switches on the **SB24** should be set to the **NORMAL** and **TTL** positions. When the power control is set to **STBY** or **ON** positions, the head and shoulders symbol appears next to the letters **TTL** for MATRIX BALANCED FILL-FLASH operation. The symbol should be steady *(F4 and N8008/F801 series)*. If not, press the **M** button once, to provide a steady symbol. The *N6006/F601 series* have their own on/off control on the camera for MATRIX BALANCED FILL-FLASH except when

*A Nikon F4 camera and SB24 Speedlight were set up for
Matrix TTL flash to record this image.
(Photo: Patrick Lauson – Sportsgraphic)*

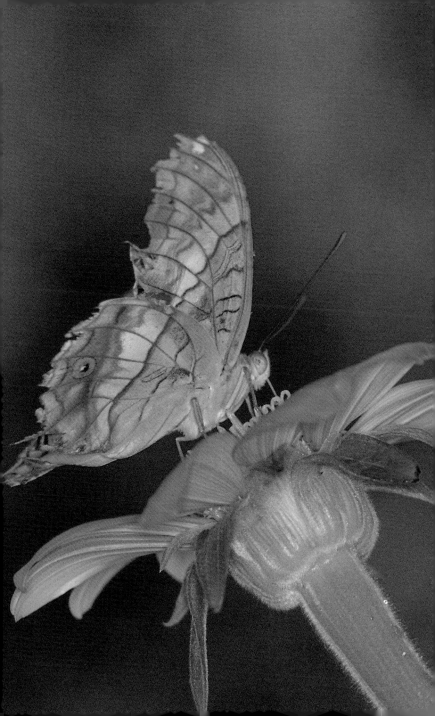

autoexposure lock or manual exposure modes are in operation. The head and shoulders symbol will not appear on the SB24 with *N6006/F601 series or N4004/F401 cameras.*

In instances where the background is particularly bright, beyond a certain E.V. level, standard MATRIX **TTL** flash is automatically chosen by all of the above cameras with the **SB24**, or any other **TTL** compatible Speedlight.

F4 series

– Provides MATRIX BALANCED FILL-FLASH with AI, AIS (manual and autofocus) and AIP lenses. AI modified lenses cannot be used.

N8008/F801, N6006/F601 series and N5005/F401x camera

Autofocus or AIP lenses must be used for any form of Matrix metering of ambient or flash illumination.

CENTRE-WEIGHTED FILL-FLASH

F4, N8008/F801, N6006/F601 and N4004/F401 series

The CENTRE-WEIGHTED FILL-FLASH mode is designed to do just that - fill in the shadows. Unlike MATRIX BALANCED FILL-FLASH, which is intended to reduce shadows on the areas of the scene it can reach, and also record the background

The top two images were taken with Matrix metering and Matrix Balanced Fill Flash respectively. The contrast on the main subject is reduced with Matrix Balanced Fill Flash.
The bottom two images show other examples of outdoor Matrix Balanced Fill FLash. (Bottom photos: P. Lawson — Sportsgraphic)

detail by controlling the f/stop and shutter speed for the available-light exposure.

The CENTRE-WEIGHTED FILL-FLASH option will always provide a flash output 2/3rds of an E.V. unit less than would CENTRE-WEIGHTED **TTL,** under the same circumstances. Correct background exposure may not be achieved, so this system is not a BALANCED FILL-FLASH type.

The amount of E.V. reduction is insignificant with colour negative and black-and-white emulsions for all intents and purposes, but a realistic amount for colour positive materials. Proof that the designers have professional users in mind.

Using CENTRE-WEIGHTED FILL-FLASH, for BALANCED FILL-FLASH

F4, N8008/F801, N6006/F601 and N4004/F401 series

With the camera set for Centre-weighted metering, the camera should be pointed at, and the exposure set for, the background (guaranteeing correct exposure). The exposure lock on the camera should be used, if in an automode, then reframe to the desired composition and take the photograph. Balanced centre-weighted exposure will result with the above cameras, and the **SB24, SB23, SB22, SB20, SB18, SB16B** or **SB15** flash units.

F4 and 8008/F801 series with SB24

The **SB24** should be set at **TTL** and **NORMAL** positions. When switched on, the head and shoulders symbol should be steady. If not, press the **M** button once to select CENTRE-WEIGHTED FILL-FLASH. Any type of lens can be used.

All other **TTL** cameras will have only the **TTL** and not the head and shoulders symbol displayed.

N4004/F401 series with any Speedlight

Only use CENTRE-WEIGHTED FILL-FLASH while in manual exposure control, or when the exposure lock button is used while in an auto mode.

CENTRE-WEIGHTED BALANCED FILL-FLASH with other TTL-compatible Cameras

With **TTL** set on the Speedlight, use manual exposure to set an aperture/shutter speed combination to provide correct exposure. DO NOT SET A SHUTTER SPEED FASTER THAN IS POSSIBLE FOR FLASH PHOTOGRAPHY while framing the camera on the background. In an auto exposure mode use the exposure lock button if available.

In any instance, recompose, and take the shot. A BALANCED FILL-FLASH picture will result.

SPOT TTL FILL-FLASH

N8008/F801 and N6006/F6006 cameras

For precise tonal measurements, with shadow area reduction, use SPOT **TTL** FILL-FLASH. Like the CENTRE-WEIGHTED FILL-FLASH mode, the actual **TTL** flash exposure is reduced at a fixed amount of 2/3rds of an E.V. compared to SPOT FILL-FLASH (standard). To achieve SPOT **TTL** BALANCED FILL-FLASH it is necessary to meter first from the background, then set the ambient exposure. Then, by using the exposure lock in auto modes or manual exposure control, recompose, switch on the Speedlight to **TTL** and shoot!

Using SPOT TTL FILL-FLASH with the SB24

Select Spot metering on the camera. The **SB24** should be set to **NORMAL** and **TTL** positions.

With the *N8008/F801* the head and shoulder symbol will appear next to the letters "TTL". It should be steady. If not press the **M** button to stop it pulsating.

On the *N6006/F601* the head and shoulders will not appear, just the letters "TTL". A camera control is used to select SPOT **TTL** FILL-FLASH rather than standard SPOT **TTL**.

4. TTL Flash Compensation - for Accuracy and Creative Control

This chapter deals with **TTL** flash compensation, necessary to achieve technical accuracy, and versatile for creative control.

During available light photography we need to adjust exposure in situations where our subject is not of an 18% reflectance. This is when subjects may be very dark or are near to pure white (pure white reflects approximately 90% of light falling on it), or when the light meter in use may be misled i.e. Back-lighting.

The same applies to flash illumination. In manual exposure control we can of course deliberately adjust aperture and/or shutter speed values, as we would in available light photography, to provide exposure compensation. In auto modes the exposure compensation control on the camera can also be used. Both will affect the ambient light and flash illumination levels. This may sometimes be required, but for many applications compensation of the flash illumination only will prove beneficial. The **SB24** can be used for both.

Using the SB24 for TTL Flash Output Compensation

F4 and 8008/F801 series

Any exposure mode can be used. The **SB24** can be set for **REAR** or **NORMAL** synchronisation. Of course **TTL** must also be set.

This feature can be used with any of the standard **TTL** systems - MATRIX **TTL**, CENTRE-

WEIGHTED **TTL** and SPOT **TTL**. The FILL-FLASH modes - CENTRE-WEIGHTED FILL-FLASH and SPOT FILL-FLASH can also be used, along with MATRIX BALANCED FILL-FLASH. The adjustments can be made in 1/3 E.V. increments

N.B. During FILL-FLASH and BALANCED FILL-FLASH operation, the camera's computer system is already adjusting the flash illumination level, as previously discussed. (CENTRE-WEIGHTED and SPOT FILL-FLASH = -2/3 of an E.V.; MATRIX = 0/-1 E.V.) Any further adjustment we make will be in addition to the camera's adjustment. In standard **TTL** flash operation no camera compensation is made.

Press the **SEL** button once. In the top right corner of the LCD a bar graph will appear.

The "+/-" sign will pulsate for approximately 8 second. During this time the **Adjust** buttons are used to take the flash illumination output from normal, up to +1 E.V., or lower it to -3 E.V. The amount of compensation set will remain on the display. If none is set, the bar graph disappears after 8 seconds.

N.B. The LCD distance scale will change as compensation is set. Reducing the compensation IN-CREASES the effective range covered by the illumination. This works in reverse when the output is raised.

The compensation value will remain, until the bar graph is recentred at the 0 point.

N6006/F601 series

A control on the camera controls the flash output compensation, again from +1/-3 E.V.

N.B. This feature is available with any **TTL**-compatible Speedlight, on the *N6006/F601 series*.

Testing the TTL compensation

I have encountered some mystified photographers who have tried to measure the **TTL** output when a compensation is set. Quite rightly they have used a separate flash meter to take an incident reading and measured the flash output. But they generally have been confused. Why?

The answer lies in the way Nikon and *all* manufacturers test the output of their flash units. What we have to do as photographers is to try, where possible, to recreate those test conditions. Unfortunately for most people this will not be possible. As a guide however, the following should enable a test to be carried out to the photographer's satisfaction.

– Use a reasonably lit room.
– Place a flash meter on a large grey card.

- Set the **SB24** to **TTL**, with no compensation, and position it approximately 3 meters from the grey card/meter. The ZOOM position should be set to 50mm, and the ISO at 100.

- Test fire the **SB24** and note the reading.

- Use the TTL compensation facility to take readings at +1, -1, -2 and -3 E.V. Compare the results. There should be nearly 1 E.V. difference between one setting and the next E.V. setting.

N.B. Owing to the minute inaccuracies which such a test may induce, small differences in the meter readings may occur from one E.V. to another. For this reason, it is not advisable to test for smaller amounts than 1 E.V. each time.

TTL Flash Level Compensation

F3, F3HP, F3T, N2020 / F501, N2000 / F301, FA, FE2 and FG

The following technique can be used with the compatible **TTL** Speedlights.

When working in manual exposure control, set the desired f/stop and shutter speed combination. The **TTL** flash illumination can now be compensated, away from its norm, by adjusting the ISO rating on the camera. As the aperture and shutter speed have been set, they will provide the required exposure for ambient light. The **TTL** flash output will change depending on the ISO value now set on the camera.

N.B. Do not go beyond the ISO range possible for **TTL** flash control.

Tip: Depending on the ambient brightness and flash to subject distance, I sometimes find that for caucasian skin, the TTL output compensation should be reduced between 1/3rd and 2/3rds of a E.V. with transparency emulsions.

Rear Curtain TTL Flash

F4, N8008/F801 and N6006/F601 series

This feature is at its most effective with slow shutter speeds, and with a moving subject, around 1 second is a good place to start your tests. The idea is simple. When the exposure starts (first curtain travel), ambient light is recorded on film. At the end of exposure the flash fires. If we take for example an exposure of a person moving from left to right, starting when the first curtain travels, we would of course record them as a blur. The flash when it fires would freeze the action at that point. The result would be a sharp image of our subject (when the flash fired), along with the blurred movement that had recorded before the flash fired. In the final image however the blurred movement follows the sharply defined image, looking quite natural.

If we took the same shot with front (normal) curtain synchronisation, the blurred movement would precede the sharp definition of our person - very unnatural. **TTL** flash compensation can be used for RC TTL. See Glossary for more detailed information.

Stroboscopic Flash

In the U.S.A. all flash units are called strobes. Strictly speaking a strobe flash (also called repeating flash) is a rapidly pulsating unit for multiple exposures on one frame.

The camera should be set to manual exposure with a slow shutter speed, to allow each pulse of flash to have an effect. As the **SB24** has a maximum of 8 pulses at 10 Hertz, a 1 second exposure is recommended when the **SB24** is powered by 4 AA batteries.

Using Strobe Flash on the SB24

With the shutter speed set as explained above in manual exposure mode, position the control switches at the top of the LCD to **NORMAL** and **STROBE** positions.

The top of the LCD will show a letter "M" and two figures. The left figure represents the number of flashes in an exposure. Up to 8 can be set. The second is the duration between each flash (Hertz).

To change the settings, press the **SEL** button once. The word "SET" pulsates. The left **Adjust** button can now be used to change the number of flashes, while the right changes the Hertz. At 10 Hertz it takes approximately 1 second to register 8 pulses.

The LCD panel will indicate the recommended flash-to-subject distance. The Speedlight will control the power output between 1/8th and 1/16th power. This is indicated on the LCD panel.

It is important that as dark a room as possible is used to limit the amount and effect of ambient light. Strobe flash is possible with all cameras offering sufficient shutter speeds for Speedlight use, and/or Bulb settings.

Light Control

One of the first things we were taught about flash photography is that direct front lighting produces a flat result, with little shape, form or contrast, as there are few shadows. This is particularly so with on-camera flash. On the plus side: if the exposure is correct, saturation of colour is good.

We can of course take the flash unit off the hotshoe, with brackets (see *Stroboframe*), via connecting leads, or in addition use multiple flash (see *Accessories*).

This will help create a modelling effect, showing shape and form.

In addition to this we can use a wide variety of diffusing materials to control the light characteristics. *To our own devices* this is what photography is all about.

I have a liking for some of the Lumiquest products, used for some of the images in this book. The "Big Bounce" is one of the range. It fits with velcro to the heads of most portable flash units. The flash head then fires the illumination into a white reflective lining. The lining, which is supported by a supple but sturdy material, then redirects the light, over a wider area compared to the flash head by itself. It is just possible to use a 20mm lens with such an accessory, and obtain an adequate angle of coverage.

The other positive effect is a diffusion or softening of the illumination. This will reduce contrast by reducing the shadow areas, lowering the harshness of some lighting set-ups. The specular highlights which frequently occur with flash illumination can also be reduced with diffusers, as they reduce the brightness of the illumination so that it is nearer to the brightness of the subject.

Another useful product range consists of large white panels which can be clipped together and are free-standing. Some of you may be using these both in the studio and on location, to provide soft lighting over a large area. This is of course a system often used with studio flash units, but the power of the **SB24** does not make them impractical. At the other end of the scale of course we can make use of everyday materials such as tracing paper. These are in addition to plastic diffusers supplied by flashgun manufacturers (see *Accessories*).

Many varieties of diffusing/reflecting materials are on the market. Often neutral white is the first choice, but gold, silver and black materials have important roles to play.

Silver reflectors direct a harsher and more "contrasty" light, while gold of course warms the

image colour, pleasing for Caucasian skin. Do not forget however that many of today's emulsions are "warm". It is up to us to choose our film with some forethought.

Black on the other hand acts as an absorbing material. This is effective in stopping "light spill" on to our subject matter. Gobo is the term often used for such products.

5. Fundamentals of Flash Photography

This chapter deals with the obvious common factor for comparing flashguns – guide number. In addition colour temperature and flash duration are also considered.

Guide number

In days gone by, comparison between flash units was based primarily on their output measured in joules (see *Glossary*). Today we quote guide numbers for comparison.

From differing units and their G.Nos. we can then see which flash unit has the greater output. It should be remembered however that a G.No. is quoted for the following criteria:

– One ISO, usually 100.

– Either in metres or in feet.

– With a specific focal length, usually 50mm.

– For a certain aperture, normally f/1.4.

– Where appropriate, a specific power ratio.

Any change to one or more of the above will need a new guide number quotation. From a guide number we will be able to use basic formulae, to work out flash-to-subject distance and the f/stop for correct exposure (see *Manual exposure control*).

ISO Ratings

For speeds other than 100 ISO, use the following multiplication factors to obtain the right G.No.:

25 ISO = X0.5.
50 ISO = X0.71.
200 ISO = X1.4.
400 ISO = X2.
800 ISO = X2.8.
1600 ISO = X4.

Focal length and output

Use this chart to obtain the G.No. when power ratio and/or **ZOOM** head position are changed.

Guide number at various film speeds meters (feet) at ISO 100

Zoom setting / Light output	24mm	28mm	35mm	50mm	70mm	85mm
1/1	30 (98)	32 (105)	36 (118)	42 (138)	47 (154)	50 (164)
1/2	21 (69)	22 (72)	25 (82)	30 (98)	33 (108)	36 (118)
1/4	15 (49)	16 (52)	18 (59)	21 (69)	23 (75)	25 (82)
1/8	10.5 (34)	11 (36)	12.5 (41)	15 (49)	16.5 (54)	18 (59)
1/16	7.5 (25)	8 (26)	9 (29)	10.5 (34)	11.5 (38)	12.5 (41)

To obtain a guide number all manufacturers use similar tests. A brief outline is given in the explanation to TTL Flash Level Compensation in Chapter 4.

Colour Temperature

On certain days of the year, in the vicinity of the American National Standard Institute (A.N.S.I.) the "temperature" of daylight is measured. From these measurements an average is found. It is this average which then acts as the standard, from which manufacturers of film and electronic flash equipment try to match the characteristics of their products. Today, the measured colour temperature is approximately 5,400 kelvin.

The **SB24** has a colour temperature of approximately 5,000k, close enough for the majority of photographic applications. Very few photographers complain that the colour of light emitted from the **SB24** is too "blue". Those that do, generally attach an amber or orange gel over the head. A word of warning: constant or rapid use will generate sufficient heat to melt some types of gel.

One of the many benefits of electronic flash is its ability to mask the colour casts associated with fluorescent and normal household lighting. Each has a different colour temperature, less natural to the eye.

The latter is an important point, because the brain adjusts to changes recorded by the eye in the brightness, and colour temperature of light, so that they both appear constant and natural to us. Film on the other hand responds to the actual colour temperature, which includes any colour cast and contrast.

Flash Duration

The time the flash illumination lasts is called the duration. What should be significant to us as photographers is making the most effective use of it when photographing fast movement. Before looking at the Nikon specification for the **SB24** flash duration, let us clarify some important points.

Once a flashgun is triggered, the illumination rapidly reaches its maximum output, or peak. After this peak has been reached, the output begins to drop, but much more slowly (timed in milliseconds) compared to the build-up time.

The recognised time quotation for flash duration by all manufacturers is the time from when the the flash has reached 50% output, passed its peak, and returned to 50% output. The remaining time the flash is on has a much lower effect on exposure than one might expect and is therefore ignored in quotation of duration times.

The output under 10% is considered to have no effect on film.

The point at which the output reaches 50%, and the quoted figure of duration starts, is called TO.5. The total time the duration lasts is called T+1.

To obtain an approximation of T+1 multiply the quoted times by a factor of 3.

SB24

Full power	(1/1)	duration	= 1/1000sec.
	(1/2)		= 1/1100sec.
	(1/4)		= 1/2700sec.
	(1/8)		= 1/5500sec.
	(1/16)		= 1/11000sec.

All durations are approximate.

As mentioned previously, choosing the appropriate flash duration is important for action-stopping photography. Even the 1/8th power output can be used to freeze the movement of water, if for instance ice is dropped into a glass full of water.

The SB24 was connected to the Nikon F4s via a SC17 TTL lead and fired into a white reflector. The camera was set to aperture priority and the shot taken through a 105mm Micro Nikkor AF, using Matrix Balanced Fill Flash.

Page 72: Matrix Balanced Fill Flash in twilight

Page 73: A multi-flash arrangement secured this photograph by Terry Pickford. Two SB24 units were used. The first was connected to the camera via a SC17 TTL lead, placed near the ground and swivelled to fire into an umbrella. The second unit was connected by an SC19 TTL lead directly to the first SB24. This was placed behind the photographer, high to the left. Matrix Balanced Fill Flash control was used. This worked perfectly with strong backlighting.

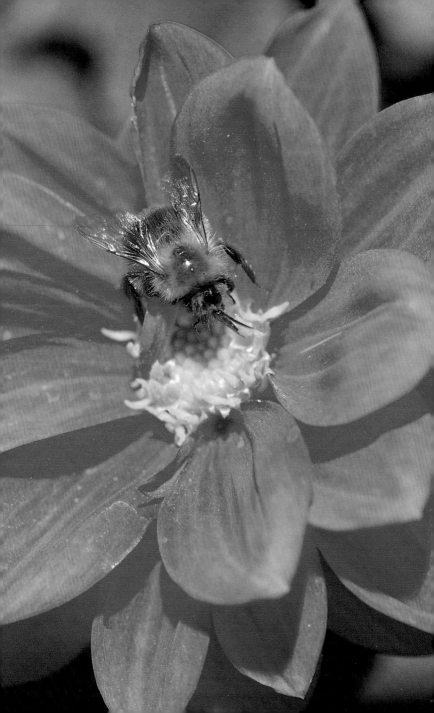

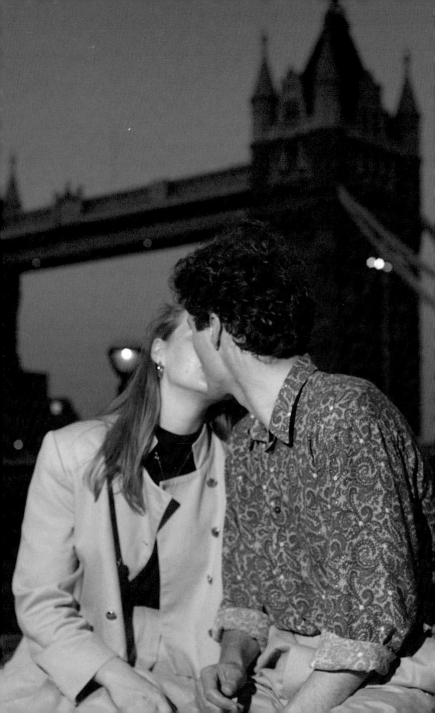

6. The Speedlight Family

To the best of my knowledge, Nikon produce the largest array of flash units, of any camera manufacturer.

Today the range consists of:

SB11, 14, 16A, 16B, 17, 20, 21A, 21B, 22, 23, 24 and **140**.

Much of the points discussed regarding **TTL** flash can also be considered for the discontinued **SB12, 15** and **18**.

TTL Speedlights for the F3, F3HP, F3AF and F3T

SB11, 14, 140 with SC12 **TTL** lead. **SB16A, 17** and **SB21A**. The discontinued **SB12** is also compatible.

TTL Speedlights for the F4, N8008/F801, N6006/F601 series, FA, FE2, N2020/F501, N2000/F301 and FG

SB11, 14 and **140** with SC23 TTL lead. **SB16B, 20, 22, 23** and **SB24**. The discontinued **SB15** and **SB18** can also be used.

TTL Speedlights for the N4004/F401 series

The **SB24, 23, 22, 21B, 16B** and discontinued **SB18** and **SB15** can be used.

Lowlight autofocus assistance is possible with the

The duration of the flash was short enough to "freeze" the water in this image. A N8008/F801 was used with a SB24, set to Matrix Balanced Fill Flash. (Photo: Jim McGukin)

F4, N8008/F801, N6006/F601, N4004/F401 series and N2020/F501 cameras.

Speedlight SB20

This unit was initially introduced with the *N2020/F501* camera in 1985. It is the second most powerful autofocus Speedlight, with a guide number of 30 meters 100 ISO. The effective range of the lowlight assist is 1/5m, with a 50mm,f/1.8 lens. A little conservative for practical use in my opinion.

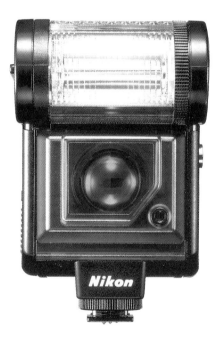

The large head contains internal diffusers. They allow the coverage to be changed for different focal lengths, without the head getting physically bigger. The widest angle covered will be 28mm. In addition, this also enables bounce flash without a change in size. The side of the head shows a letter indicating

Usable apertures/shooting distance range in A mode

Unit: m (ft)

	ISO film speed							Shooting distance range		
	1600	800	400	200	100	50	25	Zoom set at W	Zoom set at N	Zoom set at T
f/stop	8	5.6	4	2.8	2	1.4	—	1.4 ~ 11 (4.6 ~ 36)	1.9 ~ 15 (6.2 ~ 49)	2.3 ~ 18 (7.5 ~ 59)
	11	8	5.6	4	2.8	2	1.4	1.0 ~ 7.8 (3.3 ~ 26)	1.3 ~ 10 (4.3 ~ 33)	1.6 ~ 12 (5.2 ~ 39)
	16	11	8	5.6	4	2.8	2	0.7 ~ 5.5 (2.3 ~ 18)	1 ~ 7.5 (3.3 ~ 25)	1.2 ~ 9 (3.9 ~ 30)
	22	16	11	8	5.6	4	2.8	0.6 ~ 3.9 (2.0 ~ 13)	0.7 ~ 5.3 (2.3 ~ 17)	0.8 ~ 6.3 (2.6 ~ 21)
	32	22	16	11	8	5.6	4	0.6 ~ 2.7 (2.0 ~ 8.9)	0.6 ~ 3.7 (2.0 ~ 12)	0.6 ~ 4.5 (2.0 ~ 15)

Flash duration

Light output (approx.)	Flash duration (approx.)
Full	1/1200 sec.
1/2	1/1500 sec.
1/4	1/3700 sec.
1/8	1/7400 sec.
1/16	1/15000 sec.

the angle of coverage: W = wide 28mm, N = normal 35mm or longer, T = telephoto 85mm or longer.

The *F4, N8008/F801, N6006/F601, N4004/ N401 series N2020/F501, N2000/F301, FA, FE2 and FG cameras* can be used for **TTL** flash control. AUTOFLASH on other cameras is possible over a 5 f/stop range from f/2 to f/8 (100 ISO).

MANUAL FLASH with all cameras is easy to use, owing to the informative chart on the rear of the Speedlight. The power output can be controlled at full, 1/2, 1/4, 1/8 and 1/16th power. The duration is of course changed, and is slightly different to that of the **SB24**.

A standby facility is included and behaves in a similar way to the **SB24**. The Speedlight will gener-

ISO film speed	A
25	2
32	2.2
40	2.5
50	2.8
64	3.2
80	3.5
100	4
125	4.4
160	5
200	5.6
250	6.3
320	7.1
400	8
500*	8.9
640*	10.1
800*	11
1000*	13

ally switch itself off after 80 seconds to conserve battery power, following the camera's meter switching off.

During close-up photography with the SC17 **TTL** lead use the following equation and reference chart to determine the most suitable aperture:

f/stop = A/flash-to-subject distance.

A changes depending on the ISO value in use.

A PC socket allows manual connection between the **SB20** and other Speedlights via an SC11 or SC15 PC lead.

Size = 71mm(w) x 110mm(h) x 70mm(d). Weight without batteries is 260g approximately.

The guide number is 30 in meters (100 ISO). The recharge time is approximately 6 seconds with alkaline manganese batteries and 4 seconds with nicads.

SB22 Speedlight

This unit was launched in 1987. It provides **TTL** flash (appropriate cameras), AUTOFLASH and

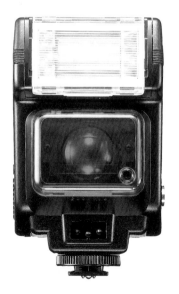

MANUAL FLASH. The guide number is 25m (100 ISO). The AF illumination is effective up to a range of approximately 15 metres 100 ISO 50mm,f/1.8 lens.

Power is supplied by 4 AA size batteries. The SD7/8 can be used. Recharge, without the SD7/8, is 4 seconds with alkaline-manganese batteries.

Bounce flash is possible with the adjustable head up to 90°. The head can also be angled down -7° during close-up photography. The head is provided with a diffuser to be used to spread the illumination for use with 28mm lenses. When not in use, the diffuser tucks away in its own little compartment. It is possible to use the **SB22** with motordrive operation as it can synchronise with six frames per second, up to four continuous shots. Normal recharge time will be on full output seconds.

Speedlight SB23

This is the smallest Speedlight available today. 64mm(w) x 67mm(h) x 84mm(d). It weighs only 140g (without batteries). When using heavy cameras such as those from the *F4 series*, you are totally unaware of the weight. The angle of coverage is adequate for 35mm or longer lenses. Four AA size batteries are the power source. The external battery packs SD7/8 cannot be used.

In low light the autofocus illumination has a range of approximately 1/5 metres. Once again I feel this may be a little conservative (100 ISO, 50mm, f/1.8).

TTL flash control with the *F4, N8008/F801, N6006/F601, N4004/F401 series, FA, FG, N2020/ F501 and N2000/F301 cameras* is possible. All cameras can use the **SB23** for manual flash operation, for which a stick-on chart in feet or metres is provided for the calculation of exposure/distance data.

During multiflash operation it is recommended that the **SB23** is used only as a "master" unit. This is because the **TTL** control position is also the **STBY** setting. Secondary Speedlights are not activated when set to the **STBY** mode. Flash duration is approximately 1/2000th of a second at full manual output.

Recycling times are 2 seconds with alkaline-manganese batteries and 1.5 seconds with nicad types. The guide number is 20m with 100 ISO films.

Speedlight SB16

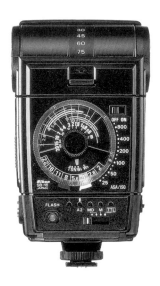

Like the **SB21** Speedlight, the **SB16** is produced in two versions designated A and B. The **SB16A** is for the F3 fitting hotshoe, while the **SB16B** is for an ISO hotshoe type.

The main body has attached a module with the appropriate connection style. The AS8 is the *F3* fitting module and the AS9 the ISO version.

The unit is larger than the **SB24** with dimensions of 82mm(d), 144mm(h) and 100mm(w) for the **SB16B**. The guide number is 32 in meters 100 ISO 50mm,f/1.4 lens. An optional wide adapter SW7 is available to cover a 24mm lens. This reduces the guide number to 19 in metres.

A **ZOOM** head feature for manual adjustment is built in. One nice little feature is the inclusion of a "fill" flash unit on the front of the Speedlight, below the main head.

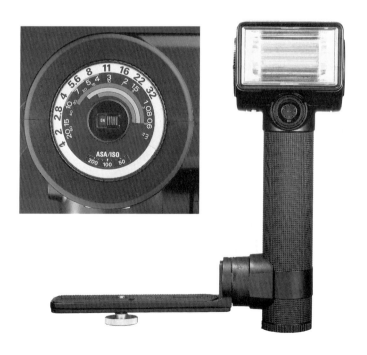

A synch socket is provided. This enables when not mounted on the camera AUTOFLASH/MANUAL FLASH operation. The same plus **TTL** flash is available when on the shoe, the latter with appropriate **TTL** flash control cameras only. **AUTOFLASH** is restricted to two f/stop options per ISO.

No external power pack is available, so the power supply comes from 4 AA size batteries. Recycling times are 11 seconds with alkaline manganese batteries.

The **SB16** was introduced in 1983, but compared to some of the ultra-advanced features of the **SB24** it seems a little longer! There would however be few who would choose the **SB16** for many of today's cameras, unless one is already owned, as the **SB24** can be considered far superior. It is cheaper too!

Speedlight SB11

This, when used with the SC12 lead, provides **TTL** flash control with the *F3, F3HP and F3T cameras*. An SC23 lead will allow **TTL** and manual operation with the *F4, N8008/F801 and N6006/F601, FA FE2, N2020/F501, N2000/F301 and FG cameras*. They attach into a socket which alternatively can also house the sensor unit SU2 for AUTOFLASH, MANUAL FLASH or modulated light transmission to trigger a second Speedlight. (Use in conjunction with the receiver from the Modulated Light 1.)

Most cameras can be connected via an SC11 PC lead for normal AUTOFLASH/MANUAL FLASH if the sensor SU2 is connected to the **SB11**. A second PC socket on the camera will allow the **SB11** to be attached simultaneously with other Speedlights for multiflash operation.

The same cameras, or those that do not have a PC socket, can be connected to the camera's hotshoe with the SU2 on top, if a SC13 is used for sensor measurement from the camera position. (Not an *F3 series* camera.)

A large hammerhead, the **SB11** has a bracket support SK4, which attaches to the camera tripod

bush. An SW3 adapter provides coverage for 28mm lenses.

The power comes either from 8 AA size batteries which are housed in the grip, or the SD7 or SD8 external power packs. They will greatly reduce the recharge time and increase the number of flashes obtained per set of cells. With just alkaline-manganese batteries in the **SB11**, the recycling time is approximately 8 seconds.

The guide number is 36 in metres 100 ISO. If the wide flash adapter SW3 is used (28mm coverage), the G.N. becomes 25 in metres. The flash head click-stops at positions up to 180° off axis. It is remarkable that the **SB24** is even more powerful than the **SB11**.

Speedlight SB14

This unit is almost identical to the **SB140.** An SD7 must be used via an SC16 lead to supply the power, as no battery holder is provided internally. It shares the same hammerhead and grip with the **SB140**.

TTL flash is available with the SC23 and the *F4, N8008/F801, N6006/F601 series, FA, FE2, N2020/F501, N2000/F301 and FG cameras.* The SC12 is for **TTL** flash with the *F3, F3T, F3HP and F3AF cameras.* A PC socket is available for non-**TTL** operation on appropriate cameras.

See the **SB140** for further information.

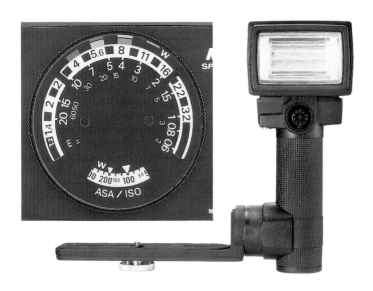

Speedlight SB140

This Speedlight is unique in the Nikon system and nearly all others in that it offers a stable and portable light source for visible light (400/900 nanometres), ultraviolet light (220/400nm) and infrared exposures (750/1100nm). The 105mm UV Nikkor is recommended for ultraviolet photography.

It will be noted by those unfamiliar with it that there is a striking resemblance to the **SB14** Speedlight. For use with normal visible light photography they are one and the same.

Three filters are supplied to fit over the flash head: SW5V for normal use, SW5UV for ultraviolet photography (300/400 nanometres), and SW5IR for infrared photography. The SK5 bracket enables the hammerhead to be attached to the camera, while the SC23 (**TTL** ISO hotshoes) or SC12 (**TTL** for *F3, F3T, F3HP and F3AF*) or SC11 synch leads are used depending on the type of photography.

N.B. TTL flash can be used only for visible light photography. (Remember the camera's **TTL** sensor is

coated to avoid UV interference.) Only manual output control can be used for UV and infrared photography. In all instances the sensor unit SU3 must be attached.

An interesting feature of the **SB140** when an SU2, rather than SU3, is attached is the ability to fire a second Speedlight remotely, with the **SB140** as the trigger. In such use a burst of modulated light is emitted from the Speedlight. If the second Speedlight is connected to the receiver from the remote control ML1 (Modulated Light 1), it would then be triggered. Guide number for visible light – 32m (100 ISO), UV – 16m, and infrared – 22m.

On full output the recharge time with alkaline-manganese batteries is 9.5 seconds, while nicads recharge in approximately 6 seconds.

WARNING: UV flash must not be used without appropriate protection for the eyes.

Speedlight SB17

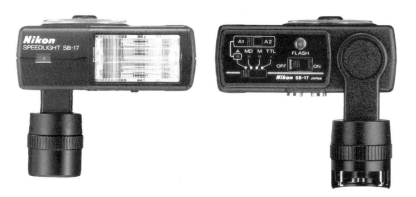

This is designed for the footing of the *F3 series*. It offers similar features to the now sadly discontinued **SB15** (ISO version). **TTL**, AUTOFLASH and MANUAL operation are possible with all *F3 cameras* except the *F3P*, which does not use **TTL** flash control. The guide numer is 25 in metres 100 ISO, which is reduced to 18 if the SW6 wide-angle adapter is used.

This allows 28mm lenses to be covered. Four AA batteries are the power source. No external power pack is available, but there is a motordrive setting for manual operation. The flash head rotates around its axis to position the tube horizontal or vertical. In addition the tube housing can be angled upwards or downwards for short flash-to-subject distances. The AS6 will convert the **SB17** to an ISO footing, but with loss of **TTL** flash control.

Speedlight SB21

All cameras

This is the only Speedlight now offered for close-up photography as the SM2/SR2 ringflash units have been discontinued. All is not lost however as the **SB21A** *(F3 fitting)* and the **SB21B** (ISO hotshoe) do offer **TTL** flash control with *F4, F3, N8008/F801, N6006/F601 series, FA, FE2, FG, N2020/F501 and N2000/F301 cameras*. Plus full, 1/4 and 1/6th manual output on all camera. The guide number of full power is 13m.

The **SB21A** can be changed to the **SB21B** simply by changing the controller unit from and AS12 *(F3)* to an AS14 (ISO) type. Both controllers house the four AA size batteries required for use.

N.B. To decrease the recharge time and increase the number of flashes per set of cells, the LD2 is recommended. Normal recharge time is 8 seconds on full output.

The other major component of the **SB21** is of course the flash head. Either can be fired independently in manual control.

To obtain wraparound illumination, the diffuser SW5 clips over the front of the head. The head is connected to the lens by a ring in either a 52mm or 62mm thread size to allow a very wide variety of optics to be used.

N.B. Users of the 60mm AF Micro Nikkor lens need to obtain as an extra the ring UR3.

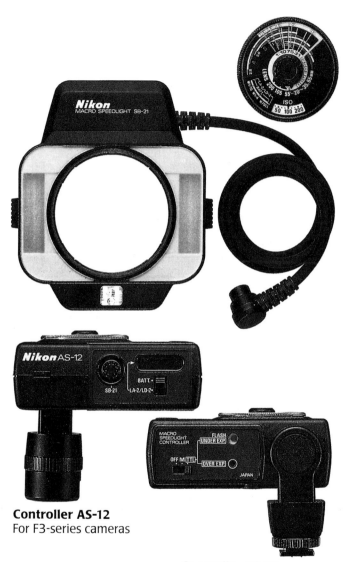

Controller AS-12
For F3-series cameras

Controller AS-14
For Nikon cameras with ISO
mounting shoe

The flash head rotates around the axis of the ring for precise lighting angle position. The SW5 should always be used when the flash-to-subject distance is less than 40mm, to reduce the risk of overexposure. Working distances greater than 40mm may benefit from its removal. The light loss factor is 1/2 f/stop. An overexposure warning light illuminates on the SB21 if required, after exposure.

Multiple Flash Photography

For more detailed information, see Glossary.

TTL or **MANUAL** flash control can be used for multiple flash photography.

Whilst using Manual flash control, PC or **TTL** leads can be used to interlink Speedlights. In addition, remote 'slave' or 'magic eyes' can trigger secondary flashguns.

For **TTL** multiple flash photography, **TTL**-dedicated leads SC17, 18, 19 and 24 are used, sometimes with connecting blocks AS10.

When using the ISO hotshoe type **TTL** Speedlights – **SB24, 23, 22, 20, 16B** and **SB15** – the SC17 is attached to the camera hotshoe if off-camera flash is required.

N.B. An SC18 or 19 can be attached to the **SB24** while it is in the hotshoe. The other end of the lead will connect into a second **SB24** or an AS10 modular block.

If an SC17 is used, a Speedlight *must be fitted* into the other end. If one is not, or is not switched on, no Speedlights connected from the SC17 terminals with SC18/19 leads for multiflash photography will be triggered, or provide ready-light indications.

Should two **SB24** Speedlights be interlinked for rear curtain **TTL** flash, only the first one on the SC17 or camera hotshoe will trigger on the second curtain travel.

Only the "master" **SB24** will display and change the information on its LCD panel that is correct, i.e. f/stop, distance scale indications and **ZOOM** head

position. The information on any secondary **SB24** Speedlights can be ignored.

N.B. You must remember to set all **ZOOM** head positons manually on the secondary or slave units.

Regardless of the type of **TTL** Speedlights used, all give an equal output when interlinked, the maximum is the strength of the unit with the lowest guide number.

It should also be noted that the **STBY** position of the **SB24, 22, 23** and **22** Speedlights cannot be used on slave units, as pressure on the shutter release will not activate them.

N.B. The **SB23** is designed so that the setting to **TTL** is also the standby position setting. For this reason DO NOT use an **SB23** as a slave unit.

The number of **TTL** Speedlights that can be interlinked varies from one type of Speedlight to another. For most **TTL** flash control cameras, five is the maximum.

Using the SB24 for Multiple TTL Flash

If required, an SC17 will take the 'master' flashgun off the hotshoe. Alternatively an **SB24** can be left on the camera's hotshoe, with SC18 or SC19 **TTL** leads plugged on to its 3-pin terminal, and act as the master Speedlight.

An SC17 with an **SB24** attached will allow SC18 or SC19 leads to be connected again to the 3-pin terminal on the Speedlight, or the 3-pin terminals of the other Speedlights.

Similar connections are then made to use further Speedlights. With more than one **SB24** it should be noted that only the master unit behaves in a fully dedicated way. The zoom head will not change automatically with secondary **SB24** Speedlights *(F4 and N8008/F801 series)*. In addition the ISO, f/stop and distance scale will not readjust on any but the 'master' Speedlight.

N.B. If an SC17 is connected to the camera, a Speedlight must be fitted into the ISO housing at the other end. If not, any further TTL lead conmnection will carry no dedication to the Speedlights in use, and will only trigger them at full output, i.e. no **TTL**, or ready-light to camera information.

The output from all Speedlights will be the same in multiple **TTL** flash operation.

The SB24 can be used for creative photography with coloured gels

7. Macro Photography

A certain type of photography that demands off-camera flash is extreme close-up or macro photography. Subjects are small and lighting must be close and precise. Flash offers the advantage of plenty of light to maintain small apertures for optimal depth-of-field and the advantage of instantly freezing the action.

Stroboframe LP Macro Flash Bracket with Nikon N8008 and SB24 Flash (*The Saunders Group*)

Stroboframe offers the LP Macro Flash Bracket which works very well with the **SB24** flash in applications such as medical, dental and forensic photography. It is designed to get the flash as close to the lens as possible by mounting it horizontally with the flash window extended. The flash is velcro-attached to a mounting block, a curved arm which allows for rotation 125° around the lens for optimum control over shadow placement. On this extremely flexible bracket the curved flash arm can be adjusted forward or backward up to 4 inches to compensate for different lenses, tilted forward almost 40° for additional lighting angles, plus raised or lowered 2 inches for different camera heights or to vary the lens to flash relationship. This bracket is essential whenever accurately directed light is of primary importance in macro photography.

Using Special Flash Brackets – Off Camera Flash

Although all Nikon SLRs have provisions for on-camera flash mounting of the **SB24**, professionals often prefer to use special brackets that provide better lighting control. Direct, on-camera flash is often harsh and unnatural, with heavy, hard-edged side shadows. Moreover, a too close flash to lens position results in "red-eye", a condition where the strobe is reflected from the inner eye resulting in an unattractive "bloodshot" appearance of the eyes on the photograph. One solution is the use of bounce flash techniques but bounce flash has its own problems and limitations. Ceiling height or the obvious lack of a ceiling outdoors can negate this technique. Anything other than a bounce unit like Lumiquest, a white ceiling or white walls can cause colour shifts. Another common bounce flash characteristic is that the overhead lighting is often aimed too directly downward. The results are unflattering with heavy unnatural shadows under eyebrows, noses and chins.

The simplest and most effective solution to the problem of unnatural lighting and hard edged

shadows caused by on-camera flash is a well-designed bracket that raises the flash to an optimum level centered directly over the lens for both vertical and horizontal compositions. The reason for this is that light appears most natural coming from above like sunlight. A good flash bracket facilitates this natural angle for lighting with the inconsistencies and complicated multiple flash-fill ratios required with bounce flash. Using a bracket raises the flash to the correct height for a natural lighting effect. Shadows fall behind and below the subject, harsh edged "ghost shadows" are eliminated even when shooting with extremely close backgrounds. When the flash is raised light becomes more natural and shadows are lowered so that they are hidden by the subject. The incidence of red-eye, caused when flash output is reflected off the retina directly back into the lens is virtually eliminated by the increased angle between flash and lens.

When using the **SB24** off camera it is necessary to use the SC17 dedicated connecting cord so that the proper contacts between camera and flash will be maintained. The **SB24** will then function in all modes exactly as if it were mounted directly on the hot shoes.

I have been very impressed with Stroboframe brackets, manufactured by the Saunders Group in Rochester, New York, U.S.A. They provide a broad choice for use with all 35mm SLR or medium format cameras. These brackets allow for the preferred high centred flash position and have a unique patented design that permits the camera to be instantly rotated between horizontal and vertical formats, while always maintaining the flash orientation. The new compact, lightweight series, Stroboframe System 2000 Brackets make an excellent choice for use with Nikon cameras and the **SB24** and SC17 dedicated cord. The camera mounts onto the brackets by using a patented anti-twist plate which locks it securely into place for perfect registration and exact 90° alignment. Anti-twist plates are available for all Nikon cameras. A low camera platform is available for use

Stroboframe RL2000 Rotary Link Flash Bracket with Nikon F4 and SB-24 Speedlight. (photo: The Saunders Group)

with the Nikon F4 and motor drive. The **SB24** with SC17 dedicated cord can be securely fastened to the top arm of the bracket by a 1/4 inch fitting.

The camera, flash and RL2000 Bracket combination is well balanced, extremely comfortable and easy to work with. The bracket has two ergonomically designed walnut grips. The side grip is for holding and firing the camera with the left hand and has a heavy-duty, professional cable release attached. The second grip, underneath, is designed for the right hand to cradle the camera comfortably while shooting. A patented rotary link mechanism permits instant rotation of the camera for vertical and horizontal compositions while maintaining the flash in

Stroboframe RL2000 Rotary Link Flash Bracket for 35 mm and medium format cameras. (photo: The Saunders Group)

the proper position directly over the lens. Side shadows and red-eye are eliminated.

The flash arm is easily positioned to adjust the angle of the flash for close-ups or distance shots. Further height adjustments may be made by the addition of an extra long (15 inch) accessory flash arm.

8. Accessories

SC17 Lead

F, N8008/F801, N6006/F601, N4004/F401
series, FA, FE2, N2020/F501, N2000/F301 and
FG cameras

When fully unwound the SC17 is 3m long. An ISO
hotshoe footing connects it to the camera hotshoe.
The Speedlight fits into the opposite end of the SC17.
This Speedlight then becomes the master unit if
using multiflash lighting, and enables *FULL* dedica-
tion between the Speedlight and a TTL-compatible
camera. Should this unit be an **SB24**, any changes to
its control will show on the LCD readout. Other
Speedlights which use the SC17 for full **TTL** dedica-
tion are: **SB23, SB22, SB20, SB18, SB16B** and
SB15.

Two 3-pin terminals either side of the SC17 Speed-
light end accept SC18 or SC19 **TTL** leads. These in
turn plug into other **SB24** Speedlights, SC17, SC24
leads or AS10 modular blocks. On the base of the
SC17 (Speedlight end) is a tripod bush. A criticism of
the Nikon Speedlight system is that no support

bracket is available. Service centres at Nikon should be able to provide an attachment (from the ML2 modulated light receiver), which will convert the tripod bush of the SC17 back to an ISO hotshoe footing. Brackets made by some independent manufacturers may then be suitable.

I have found, however, a superb range of practical support brackets made in the USA called Stroboframe (see page 93). The SC17 can still be used to maintain TTL dedication with the Stroboframe connecting directly into the tripod bush of the SC17.

SC24 TTL Lead

F4 series

For use with the DW20 (waist level) and DW21 (6 times magnifier) finders with the *F4 series*.

A 3m lead with a 6-pin connection to the above finders (no ISO hotshoe) provides the same dedication, terminal/tripod bush points as the SC17.

SC18/19 Leads

The SC18 is 1.5m long and the SC19 3m long when fully uncoiled. They connect directly into the 3-pin terminals on the **SB24** Speedlight, SC17/18/24 leads, or an AS10 modular block.

AS10

A small unit which has an ISO hotshoe for connecting to the base of the Speedlights, **SB24, SB23, SB22, SB20, SB18, SB16B** and **SB15**. It has a tripod bush on the base and two 3-pin connection points, to accept SC18/19 **TTL** leads.

AS15

In my opinion cameras that are produced today sadly seem to lack one important feature – a PC socket! Why all major manufacturers only place such an important need on the "top of the line" products I do not understand. All is not lost, however, as an ISO hotshoe of any camera that does not have a PC socket can have the AS15 connected to provide such. Unlike some independently made items, the AS15 is

designed not to poke the PC lead in your eye, and also allows a secure fit with the hotshoe. One final point – the cost: it's nicely on the low side.

SC23

This allows **TTL** flash control with the **SB11, 14** and **SB140** Speedlights, with the ISO hotshoe on the *F4, N8008/F801 and N6006/F601 series, N2020/F501, N2000/F301, FA, FE2 and FG cameras.*

SC12

For the *F3, F3HP and the F3T* cameras, to provide **TTL** flash control with **SB11, 14** and **SB140** Speedlights. (**TTL** flash is not possible with *F3P cameras.*)

SC11 and SC15 PC Leads

Any camera with a PC socket can be connected to a Speedlight having the appropriate receptor terminal. The SC11 is 34cm long, while the SC15 is 60cm long.

SC14

1.5m long and enables full dedication to be maintained between an *F3 series camera* and **TTL** compatible Speedlights.

AS4/7

The *F3, F3HP and F3T* can be connected to a standard Speedlight via one of these units. (The *F3P* already has a standard hotshoe.) They attach over the F3 flash footing. *Neither* allow **TTL** flash control, but the AS7 will enable access to the rewind crank without removal.

AS5/AS6

This will connect the F fitting Speedlights **SB16A/17** to a normal ISO hotshoe camera. **TTL** flash will not be possible.

The AS5 allows F3 fitting Speedlights to be connected to the hotshoe of an F or F2 camera.

AS11

The **SB16A/17** can be connected to a tripod with this adapter. A PC lead to the camera is the recommended attachment.

SC13

Connects to the **SB11, 14** and **140**. The other end sits in an ISO hotshoe via an AS4 complete with the sensor unit SU2. This allows AUTOFLASH from the camera position.

AS3

Allows *F2 series* Speedlights to be connected to the *F3, F3HP, F3AF and F3T cameras.*

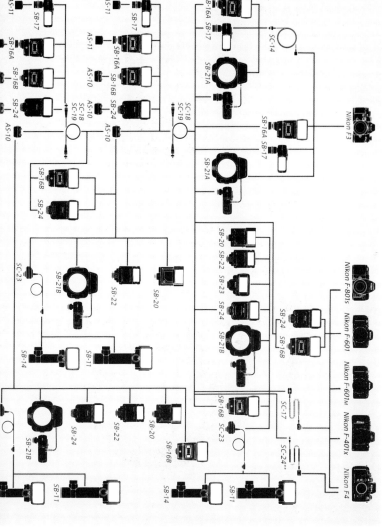

*TTL operation not possible with SB-11, SB-14 or SB-21.
**Required when using F4 with DW-20 or DW-21.

AS1

Will enable ISO fitting guns to be attached to the *F or F2 series of cameras.*

AS2

Converts the hotshoe of an *F2 series camera* to an ISO version.

Wide-angle adapters

Many of the Nikon Speedlights can be used with wide-angle adapters, to increase the angle of flash illumination coverage. Those units mentioned in this book are compatible with the following adapters:

SB11/SW3 increases the coverage to cover a 28mm lens, from a 35mm focal length.

SB12/SW4 increase the angle to cover a 28mm focal length from 35mm.

SB17/SW4 increases the angle to cover a 28mm lens from a 35mm lens.

SB14/140/SW5 increases the angle of coverage from a 28mm coverage to that of a 24mm.

SB15/SW6 allows a 28mm lens to be covered, compared to the normal coverage of 35mm.

SB16A/B/SW7 will enable coverage of a 24mm focal length, compared to the coverage of 28mm when the SW7 is not attached.

9. Do's and Don't's of Speedlight Photography

Don't:

- Fire Speedlights directly into eyes from very close distances.
- Connect a Speedlight to the hotshoe and PC socket at the same time. The resulting "trigger voltage" may damage one or all items.
- Dismantle or attempt any repairs.
- Leave a Speedlight in hot or wet conditions.
- Be tempted to use Speedlights at sporting events, theatres or pop concerts where they are prohibited (even if you obtain photographs, they may be under someone else's copyright).
- Interlink a larger number of Speedlights than Nikon recommend (see *Multiflash Photography*).
- Mix Nikon Speedlights with other makes for **TTL** flash photography. The electronic pulses used for communication differ from manufacturer to manufacturer. Also be aware of "trigger volts".
- Mix batteries from make to make, batch to batch, and type to type.
- Expect purchase of the largest, most sophisticated flashguns to make you (or your image) a great photographer. Only your own techniques, the way you use them, and good photography do that.
- Underestimate the need for all of the **SB24** features. Someone somewhere is using them.
- Underestimate your own abilities with the **SB24.**
- Initially blame the camera/Speedlight system for overexposure with colour negative film. It may just be the printing.

Do:

– ENJOY your photography.

– Make your own tests and evaluations of ANY equipment/materials, under your own working circumstances.

– Charge up the Speedlights every few weeks when not in use.

– Remove batteries if the equipment will not be used for weeks.

– Experiment with contrast-reducing FILL-FLASH and BALANCED FILL-FLASH – you may be pleasantly surprised!

– Keep things as simple as possible in multiflash photography.

10. Nikon Camera Profiles

This section will now look at all of the Nikon SLR cameras, plus the Nikonos V, and the compatibility with the **SB24**, and the Speedlight system. We have limited the comments to those of prime concern in flash photography. For more information, many cameras have been the subject of other books in the Hove series (see back cover). There may also be further information throughout this publication.

F4 (1988), F4S (1988) and F4E (1991) cameras

Fully compatible with all the **SB24** features. The top synchronisation speed is 1/250th of a second. Speeds

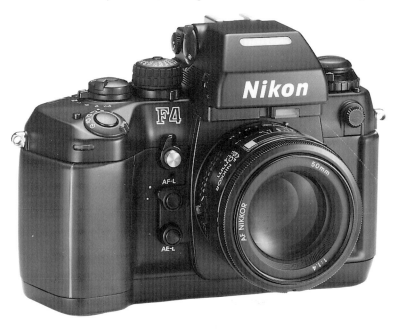

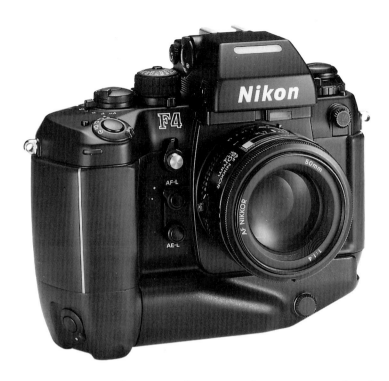

can be set on the camera down to 4 seconds, plus
Bulb and T settings. Apart from the latter, all speeds
can be used for second curtain synch, as well as first.

It is also possible for specialist requirements to use
the Multifunction backs MF23/24 to extend the
shutter time. Programmed, Programmed High Speed,
Aperture Priority, Shutter Priority and Manual expo-
sure controls are available. The three metering
systems – MATRIX, CENTRE-WEIGHTED and
SPOT – can be used for **TTL** interior flash
control, while the first two offer in addition
MATRIX BALANCED FILL-FLASH, and CENTRE-

*The use of an SB24 was made in order to change the colour temperature of the light
source. The later summer afternoon produced a very warm result. An SB24
positioned high to the right illuminated the subjects in the same
direction as the sun*

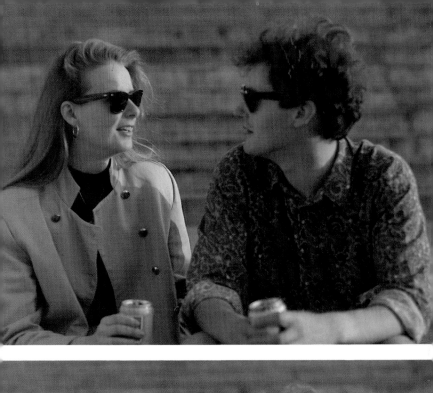
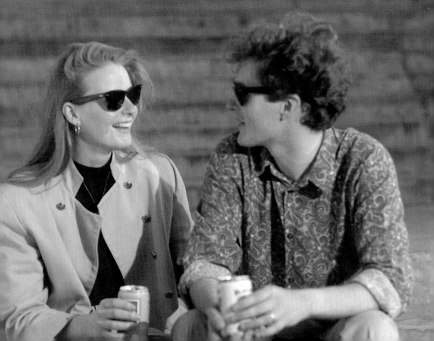

WEIGHTED FILL-FLASH. All can be fine-tuned with the use of **TTL** flash level compensation. AUTO-FLASH, MANUAL FLASH and STROBE operation are also possible.

If AF Nikkor lenses are used, the **ZOOM** head will, if required, change its position automatically.

Connection for full dedication is to the ISO hotshoe (DP20 standard finder or DA20 action finder). If the waist-level (DW20) or the six-times magnifier (DW21) are used, the SC24 **TTL** lead is required. A PC socket is also available.

N.B. For Programmed modes, and Shutter Priority operation, AF or AIP Nikkor lenses are required.

Nikon FM2 (1982)

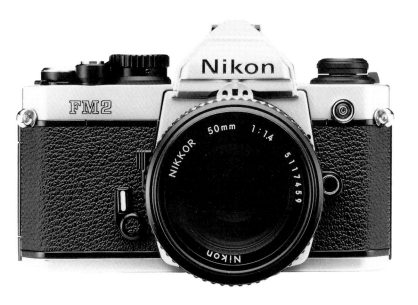

The SB24 is a powerful speedlight. Two were used here in manual output, each fitted with a coloured gel. The camera, a Nikon F4s, was set to manual exposure control and used with a Nikkor 35-70mm,f/2.8 AF lens.

At the time this camera had the fastest top synchronisation speed for any 35mm SLR of 1/200th of a second. Shutter speeds down to Bulb could also be used for flash photography.

The **SB24** can be connected via an ISO hotshoe or a PC socket.

If the MD12 motordrive is attached, the **SB24** will synchronise at 1/8th manual power output, with the top speed of 3.2 frames per second.

MANUAL, AUTOFLASH and STROBE FLASH are available.

Nikon FM2N (1984)

Nikon again introduced the world's fastest synchronisation speed in a 35mm SLR, this time 1/250th of a second. The same specifications apply as for the original FM2. AUTOFLASH, MANUAL FLASH and STROBE FLASH are available.

Nikon FM (1977)

A synchronisation speed of 1/125th of a second was the fastest possible. The **SB24** can be used at 1/8th manual power output when the motordrive MD11 (3.2 frames per second) is used. MANUAL and AUTOFLASH as well as STROBE FLASH can be used. Attachment is by the ISO hotshoe or PC socket.

F3 (1980), F3HP (1982, F3AF (1982) and F3T (1984)

The F3 series uses a unique hotshoe attachment. This means therefore that *only* Speedlights with the receptor footing, or connecting lead with the footing, can enable **TTL** flash operation. All other Speedlights do not, even if they are **TTL**-capable themselves. A PC socket is on every F3 camera.

The synch speed is 1/80th of a second for dedicated units. They can be used in Aperture Priority and Manual exposure modes. Non-dedicated flashguns can be synchronised at 1/60th of a second, and slower, including Bulb and T settings.

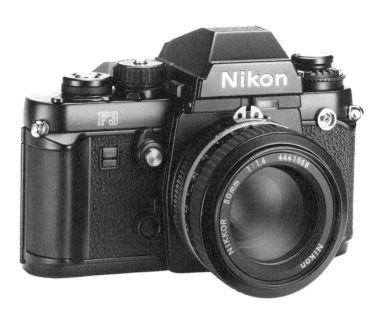

The **SB24** can be connected to the hotshoe by AS4 or AS7 adapters. Both will enable AUTOFLASH, MANUAL FLASH and STROBE FLASH photography. The AS7 sits slightly forward of the F3 body, to allow access to the rewind crank. In practice the heavily centre-weighted metering system makes for an accurate **TTL** exposure system, if aligned properly.

F3P (1983)

This version of the F3 was initially produced after a specific request from those involved in press photography. At first it was not on general release to all photographers. For flash photography, **TTL** flash is possible with F3 compatible Speedlights connected to the normal F3 hot shoe covering the rewind crank. In addition a normal ISO hot shoe is available on top of the F3P head. The same features are available as with the other F3 cameras when used in conjunction with the **SB24**.

AUTOFLASH, MANUAL and STROBE usable with the **SB24.**

F2 series: F2, F2A, F2AS, F2SB and F2H (1971/1980)

The AS1 adapter is needed to attached ISO type Speedlights. Should F3 fitting Speedlights be used they attach via the AS5. Both can be connected to the PC socket of any F2. This socket is threaded for a secure contact and should be used with the SC11 or SC15 synch leads.

The top synch speed is 1/80th of a second. All speeds down to 1 second, Bulb and T can be used for flash photography.

AUTOFLASH, MANUAL FLASH and STROBE FLASH may be used. The MD2 provided the top firing rate of 5 frames per second. The **SB24** can be used at 1/4 power output to synchronise at this rate.

F series: F, F photomic, F photomic T, F photomic Tn and F photomic Ftn (1959/1974)

All of the above had the same characteristics for flash photography. 1/60 of a second was the fastest synch speed, but all shutter speeds down to 1 second, Bulb and T can be used. ISO fitting Speedlights connect via an AS1 adapter, or an AS5 to connect an F3 fitting Speedlight.

AUTOFLASH, MANUAL FLASH and STROBE FLASH are usable with the SB24.

The F36 allows motordrive rates of four frames per second. The **SB24** used at 1/8 power output can be syncronised

Nikon FA (1983)

The original form of multipattern metering was used on this camera: AMP – automatic multipattern metering. It was not, however, used for flash photo-graphy, for which centre-weighted TTL could be used in any exposure mode. The choice? Programmed,

Programmed High Speed, Shutter Priority, Aperture Priority and Manual exposure control.

The top synch speed is 1/250th of a second, but all speeds down to 1 second and Bulb can be used for flash photography. **TTL**, AUTOFLASH, MANUAL and STROBE FLASH can be used. The MD15 is the recommended motordrive, it has a top firing rate of 3.5 frames per second. The **SB24** can be synchronised at 1/8th manual power output for use with the MD15/FA.

Attachment is via a PC socket or an ISO hotshoe. **N.B**. AIS lenses (including AF Nikkors) are used for Programmed and Shutter Priority operation. Other types lose the above exposure mode.

N2020/F501 (1986), N2000/F301 (1985)

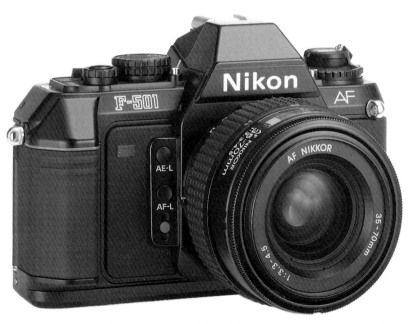

Apart from the N2020/F501 camera having a body-integral autofocus system, and therefore using low-

light autofocus assist from the **SB24, 23** and **SB20,** both cameras are otherwise the same. Each offers Programmed High Speed, Programmed, Aperture Priority and Manual exposure control. **TTL** flash of a centre-weighted type can be used with any exposure mode. AUTO-FLASH, MANUAL FLASH and STROBE FLASH operation is possible. The flash synchronisation speeds range from 1/125th of a second to 1 second, plus Bulb. The N2000/F301 was the first Nikon SLR to have a built-in motordrive. Both cameras are capable of 2.5 frames per second. The **SB24** can be used at 1/4 power output, with the continuous drive in operation. Attachment is to the ISO hotshoe.

N.B. The N2000/F301 can use any type of AIS lens for all exposure modes (including AF Nikkor lenses). If AI or AI modified lenses are used, only Aperture Priority and Manual exposure are available.

The N2020/F501 was the first Nikon camera to use only AF optics to allow Programmed mode operation. Non-AF types lose this facility.

Nikon N4004/F401

This camera was the first to offer a multipattern metering system (Image Master Control) for flash photography, in addition to available light photography.

The Image Master Control for flash can be used in Programmed, Aperture Priority and Shutter Priority exposure modes. In Manual exposure control, centre-weighted metering is used. In all instances **TTL** flash is possible. In addition AUTOFLASH, MANUAL FLASH and STROBE FLASH can be used with the **SB24**.

The synch speeds range from 1/100th of a second (all auto modes), down to 1 second and Bulb in Manual exposure control. The built-in motor does not fire in a continuous setting.

The **SB24, 23, 22** and **SB20** provide autofocus assistance in low light. All external Speedlights connect via the ISO hotshoe. It should also be remembered that

the N4004/F401 was the first Nikon camera to feature an integral flash unit (guide number 12m).

N.B. The use of AF or AIP Nikkor lenses is recommended. Without their use, only Manual exposure is possible with AI- and AIS-type lenses. The only viewfinder information in such circumstances is the flash charge/underexposure warning.

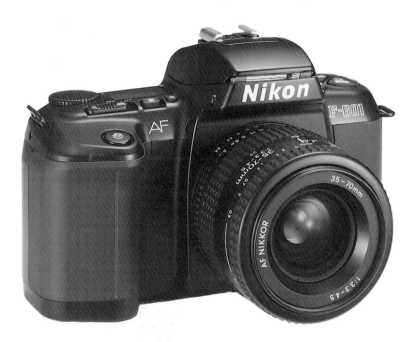

N6006/F601 camera (1990)

This incorporates the most advanced flash systems to date of any Nikon SLR that can be controlled on the camera. (I wonder whether this is a little over the top for the intended type of user?)

All **TTL**-compatible Speedlights can be controlled to give normal/rear curtain synch, **TTL** flash level compensation and slow synch flash.

Matrix, centre-weighted and spot metering can be used to provide MATRIX **TTL**, CENTRE-WEIGHTED

TTL and SPOT **TTL** flash control. In addition MATRIX BALANCED FILL-FLASH, CENTRE-WEIGHTED FILL-FLASH and SPOT FILL-FLASH are usable, all controlled on the camera.

The N6006/F601 has its own built-in Speedlight, which can be used with lenses down to 28mm. The exposure modes available are Programmed, Programmed Dual, Shutter Priority, Aperture Priority or Manual. Synch speeds are 1/125th of a second to 30 seconds and Bulb.

N.B. Only AF or AIP Nikkor lenses provided Programmed and Shutter Priority auto exposure modes, and matrix metering options.

N6006M/F601M camera (1990)

Launched with its sister camera, the N6006/F601, the N6006M/F601M offers the same on-board flash controls. It does however not offer any form of **SPOT** flash photography or a built-in Speedlight.

N.B. As with the N6006/F601, AF or AIP lenses only will provide all features.

N8008/F801 (1988) and N8008s/F801s (1991)

The camera that started it all – the N8008/F801. Launched simultaneously with the **SB24** they formed the perfect match: **TTL** flash, matrix, centre-weighted meter control, **TTL** FILL and BALANCED FILL-FLASH, with either meter system. AUTOFLASH, STROBE FLASH, full MANUAL FLASH control, automatic angle of coverage change, **TTL** flash level compensation and rear curtain synch. Perfect? Not quite, as the N8008s/F801s has added SPOT **TTL** and SPOT FILL-FLASH to this impressive arsenal.

Top synch speed is 1/250th of a second, down to 30 seconds plus Bulb. This can be extended when used with the multicontrol back MF21. With AF or AIP Nikkor lenses, Programmed Dual, Programmed, Shutter Priority, Aperture Priority and Manual exposure modes can be used. With non-AF or AIP lenses,

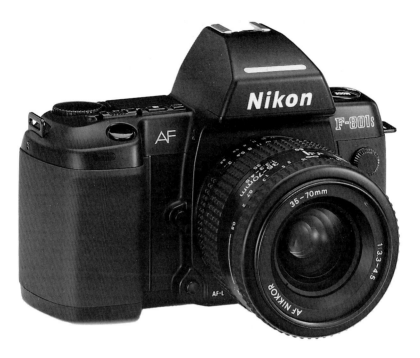

the Programmed and Shutter Priority modes would be lost, along with matrix metering controls.

N5005/F401x camera (1991)

The incorporation of matrix metering into this camera allows MATRIX BALANCED FILL-FLASH to be used. If the shooting criteria are unsuitable, MATRIX TTL (standard) flash is automatically selected. It can be used in Programmed, Shutter Priority and Aperture Priority, whilst Manual exposure uses only CENTRE-WEIGHTED FILL-FLASH. If the situation requires it, CENTRE-WEIGHTED FILL-FLASH (standard) is selected.

AUTOFLASH, MANUAL FLASH and STROBE FLASH can be used with the **SB24**. The synch speed is set to 1/100th of a second in auto modes, while 1/60th to 1 second plus T can be used in Manual

exposure control. Connection is to the ISO hotshoe. The N5005/F401x carries on the N4004/F401 tradition of incorporating a built-in Speedlight, which will cover lenses down to 28mm. There is no continuous motor-drive operation.

N.B. The SB21 close-up Speedlight cannot be used with the 4004x/F401x.

N4004s/F401s camera (1989)

For flash photography, no significant changes were made from the original N4004/F401 camera.

N.B. The **SB21** close-up Speedlight cannot be used with the N4004s/F401s.

EL2 (1977), ELW (1976)

Both cameras have a threaded PC socket or ISO hotshoe for Speedlight connection.

Shutter speeds 1/125th of a second to 4 seconds plus Bulb (ELW), and 1/125th of a second to 8 seconds plus Bulb (EL2) are usable.

STROBE, AUTOFLASH and MANUAL FLASH can be used.

ELW motordrive rate was 0.5 frames per second. A 1/4 power output can therefore be used on the SB24.

FG20 (1984)

The synch speed was 1/90th of a second. Slower shutter speeds cannot be used.

The MD14 gave firing rates up to 3.2 frames per second. The **SB24** on 1/8th power manual output will synchronise with this speed. Connection is by the ISO hotshoe or to the PC socket. AUTOFLASH, MANUAL FLASH and STROBE FLASH are possible.

EM (1979)

The first polycarbonate Nikon. It sold in incredible numbers. The synch speed was 1/90th of a second.

Connection is to the ISO hotshoe only. AUTOFLASH and MANUAL FLASH are available.

Nikon FG (1982)

TTL control with all exposure modes, High Speed Programmed, Programmed, Aperture Priority and Manual. It is a centre-weighted **TTL** system. The flash synchronised up to 1/90th of a second or down to 1 second, plus Bulb. Attachment is by the ISO hotshoe or socket.

AUTOFLASH, STROBE FLASH and MANUAL FLASH are available, with the **SB24** at 1/4 power, synchronising with the camera when an MD14 is attached.

FE2 (1983)

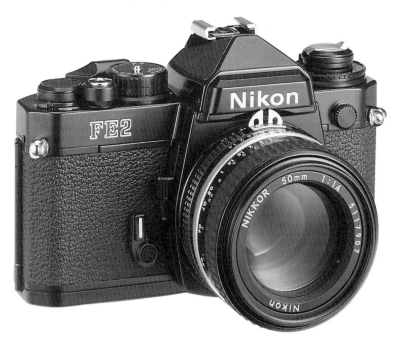

Was the first 35mm SLR to have a 1/250th of a second top synchronisation speed. Speeds down to 1 second plus Bulb can be used for flash photography.

AUTOFLASH, MANUAL FLASH and STROBE FLASH can be used. With an MD12 motordrive the **SB24** can be used at 1/8th power manual output.

Attachment is via the ISO hotshoe or PC socket. TTL flash can be used in both Aperture Priority and Manual exposure modes and is controlled by a centre-weighted metering system.

Nikkormat FTN (1967)

This camera was first produced in 1967. Originally it did not have an ISO hotshoe, but an optional extra was later produced to provide such.

All FTN cameras have a PC socket for connection to the **SB24, SB22, SB20, SB17, SB16A/B, SB14/140, SB11, SB21A/B**.

The **ZOOM** head has to be manually set. AUTOFLASH, MANUAL FLASH and STROBE FLASH are usable with the **SB24**.

Nikkormat FT2/3

The FT2 was produced in 1969, and the FT3 in 1974. They use the same features as the original FTN, and are connected in the same way to the SB24. The Speedlights as listed above can also be used.

FS and FT (1965)

Both cameras had a PC socket. No ISO hotshoe was supplied as standard, but an optional hotshoe was available. Top synch speed was 1/125th of a second with speeds down to 1 second also usable.

AUTOFLASH, MANUAL FLASH and STROBE FLASH are possible with the **SB24**.

Nikonos V Underwater Camera (1984)

For photography on land, Nikon produce a TTL land use lead, compatible with all of the ISO Speedlights. It allows the Speedlight to be positioned up to 1.5m away. The metering is a centre-weighted type. There is the normal ready-light information in the camera's viewfinder.

I have also become aware of an increasing number of Nikon SLR cameras being used inside a protective housing along with the **SB24** for underwater use. They are connected by an SC17, some photographers prefer this combination to the Nikonos V and underwater Speedlights **SB102/3**, owing to the **SB24's** greater power. It should be remembered that both the glass/plastic housing and the water will greatly reduce the effective power output.

The End of the Story

To state that the **SB24** is impressive is an understatement. The ability to work with and be controlled by a camera computer, allowing for complete point-and-shoot photography, is a godsend not only to the amateur but also to the professional who needs to work rapidly.

It would be unfair however to dwell only on this point, as the **SB24** is compared to all other hot shoes flashguns currently available as the most comprehensive in allowing a photographer to work on their own devices, with an incredible array of exposure options. It is no surprise to see other manufacturers reproduce some of the **SB24** features in their own units.

The Speedlight system as a whole dwarfs most of the other camera manufacturer's systems and credit should be given for the versatility this allows many photographers. I have had a complete book to allow me to make my own observations. It is hoped that those owning a **SB24** will now be able to use it much better informed than just relying on Nikon's own booklet that accompanies the product. Also that those contemplating the purchase of an **SB24** will see what a marvellous piece of equipment it really is!

Glossary

AI

Is the name given to lenses produced between 1977 and 1981. They could be mounted on an appropriate SLR without aligning a particular f/stop and meter coupling prong, to reduce the time taken for a lens change.

AIP

To date only one lens, a 500mm,f/4 manual focal has been produced as a P lens. Put simply, a CPU has been incorporated inside the metal body. This enables the same transfer of information to the camera body as an AF lens. The 500mm,f/4 P is of course an AIS type of lens.

AIS

Have been produced since 1981 for both manual focus lenses, AIP and AF lenses (since 1985). The internal mechanism for controlling the iris diaphragm is different to AI lens types. It allows what we term a "linear" control of the diaphragm. This is necessary for Programmed and Shutter Priority operation. AIS lenses are distinguished by the smallest f/stop marked in orange. On the rear of the mount, an index depending on its depth, enables manual AIS lenses to "inform" the body of its focal length. AF lenses and AIP optics use CPU technology to provide this information to the camera CPU.

Ambient light

Is the term used to describe a constant source of lighting, rather than an instantaneous one. When using flash illumination with ambient light we

actually refer to any available light, such as daylight or tungsten illumination.

Aperture

The opening in the diaphragm of a lens, through which light passes to reach film (see also f/stop and *diaphragm*).

Aperture Priority

Works in reverse of Shutter Priority. Enables a particular aperture to be set on the lens. This aperture will then always be used. The camera automatically adjusts the shutter speed to obtain correct exposure, with ambient light or flash illumination.

Autoflash

The first form of controlled measurement for flash exposure. A sensor on the face of a Speedlight responds to flash illumination as it returns towards the camera from the subject. When enough has returned, the flash unit's output is quenched. (The amount is decided at the design stage.)

Backlighting

Is the term used to describe a subject that has a strong light source illuminating it from behind.

Some of the top speed skiers use photography to analyse how different types of clothing and body stance will affect their speed. Here David Higgs has used three SB24 units; two for backlighting, each with a coloured gel attached, and one on the camera – A Nikon F4s. All equipment was used manually, with the slave speedlights triggered by a radio remote control. The exposure was approximately 5 seconds while a chemical fog was blown onto the skier at wind speeds in the region of 100mph.
(Photo: David Higgs)

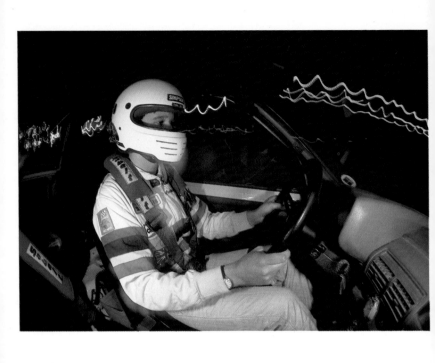

Balanced Fill-flash

Is the correct term when the flash illumination is controlled to illuminate a subject, while the aperture and shutter speed values expose the background correctly or nearly correctly with ambient light. This allows a balance in exposure between the two.

Centre-weighted

Is the term given to a light measurement system bias to the centre of the picture area.

CPU

Is a central processing unit.

Cybernetic Synch

Although not used in this publication, this Nikon term refers to the electronic control of the shutter, for proper synchronisation with TTL-compatible Speedlights. A cyber is an electrical component that performs a task, in this instance shutter synchronisation control.

Exposure Factor

Refers to an increase in exposure greater than is normally required for correct exposure. This is necessary when using accessories such as filters and extension bellows.

This is another image which combines a long exposure with flash illumination. In order to get the desired composition in a restricted space, a 16mm full-frame Nikkor lens was used. Two SB24 Speedlights, one each side of the camera, gave sufficient coverage. They were triggered at normal curtain travel, while the total exposure time was in the region of 10 seconds.
(Photo: David Higgs)

Fill-flash

The strength of the flash unit's output is controlled to enable its output to be kept at a strength lower than the effect that ambient light will have on the scene. This will reduce contrast because the flash will illuminate the shadow areas.

Flash-to-subject Distance

For correct exposure calculation in manual flash control the distance for any calculation must be from the flash unit to the subject.

Flash Tube

The unit which contains the inert gas which ignites to provide the electronic "flash".

Guide Number

The quoted number indicates the actual strength of flash illumination. It is quoted in metres or feet, usually with a 50mm,f/1.4 lens and on ISO emulsion of 100.

Incident Light Reading

Is made generally with a separate hand-held exposure meter. The measuring surface is pointed towards the light source, to measure the strength of illumination falling on and not reflected from the subject. The reflectance value will not affect the exposure.

Joule

Named after J.P. Joule (1818/89). It is equivalent to one watt-second. In photography they are used to indicate the power discharged from a flash tube, where the type of reflector and shooting environment are not considered. This differs from a guide number quotation, which does take the above into consideration.

Kelvin

Is the standard unit measurement for colour characteristics of a light source. Quoted in degrees Kelvin.

LCD

Stands for liquid crystal display. Images and characters are formed when an electrical charge is passed through liquid crystal. The type of LCD on the **SB24** is called a twisted nematic.

Matrix

Is the name given by Nikon to a light measurement system and computer programme developed to interpret the scene's brightness levels and make adjustments in order to obtain a "technically" correct exposure.

Micro Processing Technology

Is the term used in the computer and electronic world to describe the electronic components, such as CPUs which evaluate or process data.

Multiflash

The use of two or more Speedlights synchronised together, so all have an effect on an exposure.

Multiple Flash Photography

The illumination that one speedlight provides can have its characteristics changed by the use of diffusers, reflectors and filtration. In certain areas such as press photography, single source lighting is common, due to the restrictions of the working environment. Many other types of photography will benefit, however, from multiple flash illumination but you must remember not to increase the number of units used, purely for the sake of it.

If you look closely at David Higgs' image on page 128, you are in fact looking at a two-unit lighting set-up. This image was taken with a full frame 16mm Fisheye lens which allowed the desired composition in such cramped conditions. To cover the entire picture area two speedlights, one either side of the camera were used. They were set to provide Matrix Balanced Fill Flash.

Other types of photography would benefit from an even illumination provided by two speedlights. These include close-up photography and flat copy work in general, such as paintings or documents. The Stroboframe system should be considered for positioning the flash units for this type of work. In most other types of photography, however, a modelling effect is desired, to provide a "lift" of the main subject, giving a three dimensional feel to the image.

Nomenclature

This is a system of naming used to title operational elements and parts.

Realtime

Instantaneous action performed by the camera, lens and Speedlight electronics.

Rear Curtain Synchronisation

Allows the flash to be triggered at the end of an exposure, after ambient light has been recorded on film.

Rear Curtain TTL Flash

(F4, N8808/F801, and N6006/F601 series)

During the section dealing with TTL flash, rear curtain synchronisation was mentioned briefly. Until recently this was used by only a few photographers, as it was not a simple technique to master. The SB24 has helped to change that by simplifying the task

It has achieved this by incorporating rear curtain synchronisation in the TTL flash mechanism. What is clever is the ability to use all of the camera's metering options, with or without TTL compensation. This allows speed of operation and the ability to fine-tune the exposure to the standard that professionals demand.

To use rear curtain synchonisation set the SB24 control buttons to the REAR and TTL positions, when using the *F4 or N8008/F801 series*.

All normal information is transferred between the body and speedlight, i.e. focal length indication, ISO rating, and f/stop. The LCD panel will show a recommended shooting distance, if the head is in the normal or -7° position.

When using a camera from the *N6006/F601 series*, a control on the camera is used to select rear curtain synchronisation when required, and not on the SB24. This makes it possible to use all TTL dedicated Nikon flashguns for rear curtain TTL flash with the *N6006/F601 series*.

Standard TTL flash when the Head and Shoulder symbol is pulsating, or one of the fill flash options when the symbol is steady, can be selected. As with normal front curtain synchronisation, the camera will control the flash illumination and automatically

133

change it from a fill flash operation to standard TTL flash if this is necessary For simplicity the photographer can therefore set a fill flash mode, which will be adjusted by the camera if required, to a standard TTL exposure. Pressing the M button will allow a manual change from one TTL mode to another, if the camera is from the *F4 or N8008/F801 series*. A control on the *N6006/F601 series* is used for the same task.

The image on page 36 was created by Mike Rushton of *Prosport*, using Matrix Balanced Fill Flash with rear curtain synchronisation. This is typical of subjects which benefit from such a technique. The SB24 was hotshoe mounted and powered by an SD8. The camera was set on predictive autofocus and the exposure was made at 1/60 second. The lens was a 20mm,f/2.8 AF. The camera was panned to create the background blur. If you look at the logo on the front wheel arch you will notice that a secondary or ghosting image has been recorded behind the sharply-defined logo.

The stable image was recorded by flash right at the end of the exposure. The ghosting image was recorded prior to the flash firing, and has recorded as a blur due to the movements of the motorcycle during the 1/10 second exposure. You can also notice a similar effect on the exhaust pipe. This image creates the feeling of movement in a natural way.

If front curtain synchronisation had been used the blurred image would have been recorded in the picture in front of the sharp logo. If anything, it would have made it seem as if the bike was moving backwards. This would certainly have been rejected for publication.

Of course if the subject matter had been moving at a slower rate, i.e. a person walking, no significant difference would have been discernible between front and rear synchronisation. It is important to think about the speed of the subject movement, and relate that to the shutter speed you intend to use to obtain the very best from rear curtain synchronisation. I

have come across many photographers who now leave the SB24 set to rear curtain synchronisation all the time, because conventional photographic images, when recorded with normal synchronisation speeds, still look natural.

Red-eye

The plague of many otherwise good photographs, red-eye is caused (only in some people and animals) when flash illumination is reflected back from the retina of the eye. As in a camera lens, our iris in the eye controls the amount of light reaching the retina by closing down or opening up.

In low light it is naturally wide, to allow sufficient light through. Unfortunately when a flash fires its short duration is too quick for the iris to respond. The flash illumination then illuminates the retina and is recorded as red on film.

The most effective way to combat red-eye is to add ambient illumination, allowing the iris to close down. When the flash fires, the iris muscles will not have to move so much and the chances of red-eye are reduced. Moving a flashgun off axis will also reduce the chance of red-eye (see section on *Stroboframe*).

Shutter Priority

Works in reverse of Aperture Priority. Enables a particular shutter speed to be set on the camera. This speed will then always be used. The camera automatically adjusts the aperture value to obtain correct exposure, with ambient light or flash illumination.

Speedlight

The Nikon name for their flashguns.

Spot Metering

Refers to a light measurement system from a very small central point in the picture area. **N.B**. A true spot reading is a 1° measurement. Most manufacturers however call slightly larger areas spot metering.

Strobe Flash

Should be called stroboscopic flash. A series of rapid flashes is used to record subject movement consecutively, on one frame.

The use of a completely blacked out room will enable the greatest effect. In addition a relatively slow shutter speed, e.g. 1 second, is recommended.

Synchronisation

Is the name given to the capability of firing a flash unit when the shutter is completely open. This enables the entire picture area to be illuminated. Improper synchronisation will be depicted by a black line horizontally or vertically on the frame.

Synchro Sunlight Photography

See *Balanced Fill-flash*.

Through The Lens

As the term suggests, the illumination that has exposed the subject reflects into the lens and from there the film emulsion. Not all of the flash illumination is absorbed by the film, some bounces off onto a flash measurement sensor. This then sends a sign to the speedlight when enough light has been received for correct exposure. The Speedlight then quenches its output.

Vignette

Shows a reduction in illumination that is recorded at the edges of a frame, compared to the central areas.

Working Distance

Is the distance between the front element of the lens and the subject

ACKNOWLEDGEMENTS

There are of course many people who I would like to acknowledge for their help in making this book possible. Therefore I would like to express my gratitude and thanks to the following people:

To Caroline, for her never ending support and encouragement. To our friends Graham Fitzgerald, Brett Margollis, Kevin and Joanne Carter, Patrick Lauson and Paul Harris. Some of whomare photographers in their own right and have contributed some of their work to this book.

In addition, the following photographers have contributed to the second edition: Mike Rushton *(Prosport)*, David Higgs, Terry Pickford and Jim McGukin. Thank you all.

To the employees of Nikon U.K. in particular:-
Harry Collins, John Pitchforth, Ron Powrie and Tony Tuckwell.

To Alan and Margaret for their hospitality, while this book was written.

Notes

Notes

Notes

Notes